IMAGES
of America

WEST MILFORD

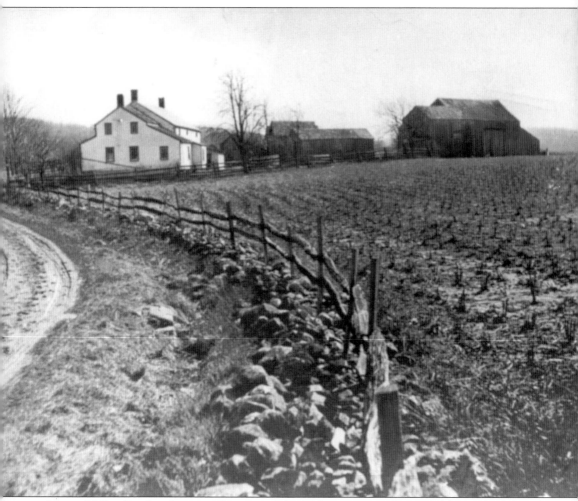

Union Valley Road is shown at the start of the 20th century, with Brookdale on the left and the Manchee Barn on the right.

This volume is dedicated to the memory of Louis Wallach Jr., who gave West Milford a lifetime of dedicated service.

IMAGES
of America

WEST MILFORD

Samantha Vaughan

ARCADIA

First printed in 2001.

Published by Arcadia Publishing,
an imprint of Tempus Publishing, Inc.
2A Cumberland Street
Charleston, SC 29401

Printed in Great Britain.

Library of Congress Catalog Card Number: 2001088725

For all general information contact Arcadia Publishing at:
Telephone 843-853-2070
Fax 843-853-0044
E-Mail sales@arcadiapublishing.com

For customer service and orders:
Toll-Free 1-888-313-2665

Visit us on the internet at http://www.arcadiapublishing.com

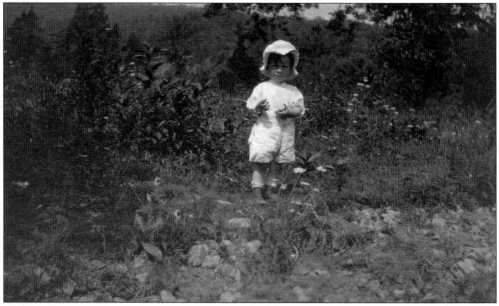

Charles Everett Wilson, age two, was photographed by Gertrude Terhune in August 1915. The location is the Terhunes' house on Union Valley Road (Brookdale).

On the cover: This photograph of Thorn's Store on Union Valley Road was taken after a portion of the building had been destroyed by fire. The original structure is pictured on page 25.

CONTENTS

ACKNOWLEDGMENTS

This book is not really my own personal creation but rather a compilation of collections and research from West Milford and regional residents. Without these individuals—who have been caring for images of West Milford's history for years and researching the factual background corresponding to those images—this book could not have been independently created in the present day. It was incredibly difficult at times to distinguish the facts correctly and to avoid attributing landmarks to one section of the township when they really belonged in another. I was aided in my research by Susan Maier of the North Jersey Highlands Historical Society (NJHHS), Rob Sparkes of Friends of Long Pond Ironworks (FOLPI), and the West Milford Historical Preservation Commission. I am very grateful for Susan Maier's guidance and facilitation of access to historical materials in the collection belonging to NJHHS and to FOLPI. Individuals such as Rob Sparkes, Jim Van Hooker, Bob Kochka, and others offered priceless tidbits helping to distinguish images from one another. I am pleased that the author proceeds of this book will benefit NJHHS, FOLPI, and the West Milford Museum (WMM) in equal shares.

I am incredibly grateful for those who loaned images from their collections for use in this publication, including Stephen M. Gross of Warwick, William Wurst of Clifton, and Harry Rescigno of West Milford. I know that they are thrilled to share their images with the public, and we are thrilled to peruse them. Additionally, individuals who have donated images to the NJHHS and the WMM for preservation and sharing with the public cannot be commended highly enough or often enough. I regret that I cannot list all the donors here, but I must mention a few: Barbara Cordero (Cross Castle collection), Russell Carey (Thorn's Store), and Margaret Taggart (Echo Lake and Macopin postcards). Without the generosity of individuals such as these, creating a central repository of such images for future generations would be an impossible task.

I am grateful to the management and my associates at the Prudential Insurance Company of America. Prudential allows flexible working arrangements, and everyone made every effort to accommodate my hectic schedule, which allowed me to visit various historical sites and spend the time I needed to complete this publication.

I must thank my husband, parents, friends, and incredible editor Peter Turco for supporting me during this process. Their encouragement was invaluable to me. Finally, I must thank Johnny Cahoon of Belfast for finding fascination with my historical activities and inspiring me in turn.

For as many photographs as are in this volume, there are many more West Milford photographs yet to be discovered. We are fortunate that there are individuals willing to share their collections with us for scanning and use and that others have donated their originals to the WMM for scanning, use, and preservation. It may seem that some areas of the township are underrepresented in this volume, as it is difficult to create a balanced volume on several different communities, each of which could justify its own book. We had to select the best of the images that we had available, but let that be an encouragement for readers to start a journey of their own to help us uncover the past, to share with future generations. The WMM may be contacted through its Web site at www.westmilfordmuseum.org to arrange for images to be loaned for scanning or donated to the museum.

RESOURCES

Books:
The Earth Shook and the Sky Was Red: A Bicentennial History of West Milford, Inas Otten and Eleanor Weskerna, 1976.
Newfoundland in Story and Picture, Newfoundland Village Improvement Society, 1904.

Articles:
"Cross' Castle," Leslie L. Post, as it appeared in the *North Jersey Highlander*, Fall 1972.
"Clinton and Its Surroundings", J. Percy Crayon, as reprinted in the *North Jersey Highlander*, 1967.
"Forgotten Village of Charlotteburg," Fred J. Talasco, as it appeared in the *North Jersey Highlander*, Winter 1971.
"Gloria: The First American Mail Rocket Flight," Stephen M. Gross, January 1996.
"Ice Cutting Days," Leslie L. Post, as it appeared in the *North Jersey Highlander*, Winter 1967.
"Notes, Queries and Replies," Vol. III, Third Series No. 3, Proceedings of the New Jersey Historical Society, July 1906. Reprinted in the *North Jersey Highlander*, 1961.

Pamphlets and booklets:
"Echo Lake Baptist Church Directory of Members and Friends."
Idylease and Brown's Inn advertising booklets.
"Long Pond Ironworks National Historic Landmark," Long Pond Ironworks 2001 informational pamphlet.

INTRODUCTION

West Milford Township is renowned for its natural beauty and resources. It is not known for a cohesive identity among its residents. Being spread over an area of more than 80 square miles, the town developed into clusters of populations in various areas, which evolved into separate hamlets or villages. Today, many of these areas maintain an identity different from the others, and even have separate post office designations.

Residents of West Milford Township, when away from home, may indicate that they are from West Milford. Yet, the closer they are to home, the more likely they are to refer to themselves as being from Oak Ridge, Newfoundland, Hewitt, or Upper Greenwood Lake. Even within these designations, sub-designations exist to describe various lake communities or developments that could be as large as other New Jersey towns.

Each area of the township, which was incorporated in 1834, developed its own sense of identity and history that were different from those of other parts of the township. Even today it could take up to 35 minutes to drive from one part of the township to another. So it is understandable that throughout West Milford Township's history (including today) many residents never travel to all parts of the township.

I had always been casually aware of West Milford's identity phenomenon, but it became more of a primary awareness as I began attempting to compile and digitally restore images for this book. I finally decided to organize them by the manner in which West Milfordites classify themselves, dividing the book into geographical sections and chapters for special places or notable events.

West Milford has an incredibly detailed history, from the earliest iron and ice-cutting industries to farming and, later, to the thriving tourism of the early 1900s. In West Milford today, there are few remnants of some of the township's once beautiful places or most impressive structures, such as Cross Castle or Moe's Tavern. Most new residents (and many older residents) of the township either never knew of these splendid treasures or had only a passing familiarity with them.

I hope that *West Milford* will bring forth the splendor of West Milford as the historic "Heart of the Highlands" for newer residents to discover for the first time and that it will bring back happy memories of yesteryear for older residents. I am content knowing that this volume will preserve many of these newly restored images for generations to come. Most of all, I hope that all will enjoy this pictorial account of our heritage as much as I enjoyed preparing it.

—Samantha Vaughan, April 2001
Vice-Chair, West Milford Township Heritage Committee

One

HEWITT

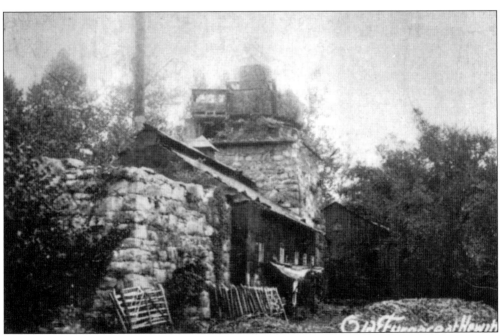

The Old Furnace at Hewitt was part of the Long Pond Ironworks facility. Long Pond Ironworks was named for nearby Greenwood Lake, which, at nine miles long, was called Long Pond by the local Native Americans. The village of Hewitt grew up around the ironworks, and the region (and one post office in West Milford) is still known as Hewitt today. (Courtesy FOLPI.)

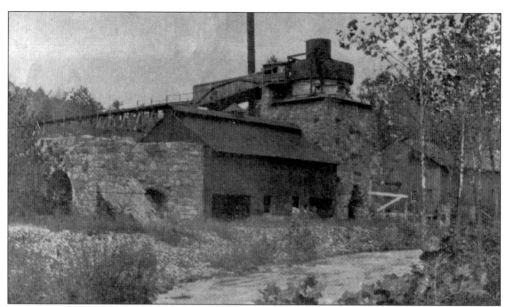

Long Pond Ironworks was founded in 1766 by Peter Hasenclever, an ironworks master from Germany. Hasenclever purchased the 55,000-acre Long Pond Ironworks land as well as the nearby Ringwood Ironworks. He had investment backing from British bankers and brought in more than 500 European workers and their families to operate the facilities. Ironically, Hasenclever's British-funded ironwork operations in America produced iron for the Continental militia, including iron used to forge the chains that blocked British naval access to the Hudson River. (The chains themselves were not made at Long Pond.) (Courtesy FOLPI.)

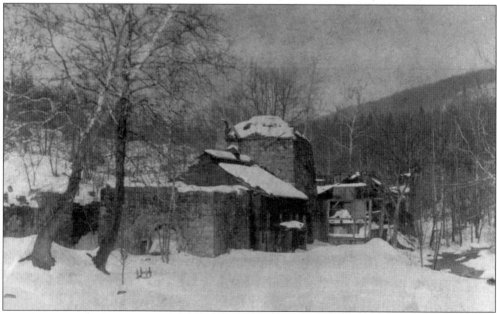

Hasenclever was replaced as ironworks master by his investors, who found his plans too extravagant and costly. The ironworks remained in operation until April 30, 1882, when coal fields and iron mines in Pennsylvania and elsewhere proved a more efficient source of ore. (Courtesy FOLPI.)

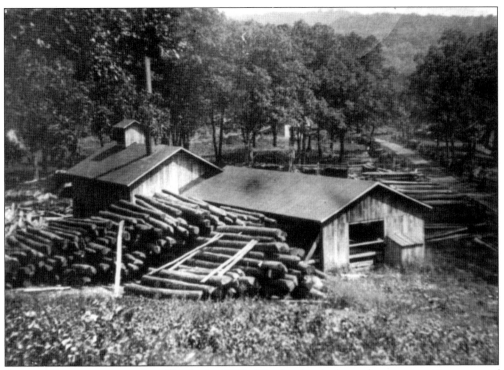

A sawmill was constructed at Hewitt in 1913. The lumber industry became a main source of income for Hewitt residents after the ironworks ceased operation. (Courtesy the Louise Terhune Collection, FOLPI.)

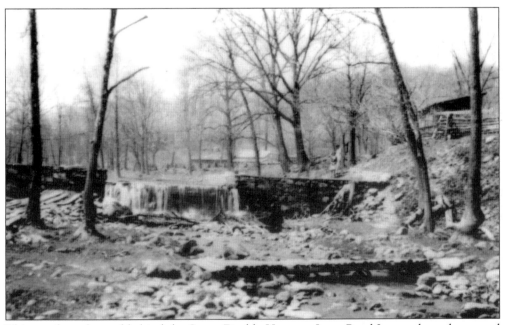

This pond was located behind the Stone Double House at Long Pond Ironworks and was used to harvest ice during the winter. (Courtesy FOLPI.)

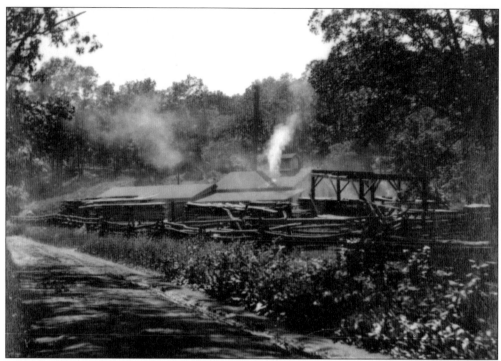

An opposite view of that on the previous page, this image shows the 1913 sawmill at Long Pond. (Courtesy the Louise Terhune Collection, FOLPI.)

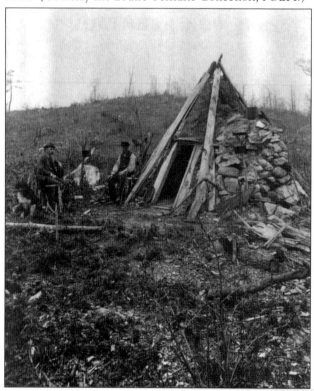

Stone and wood structures were used to turn local timber into charcoal. Using timber for construction or conversion to charcoal was a continuous activity at the ironworks. This photograph was taken in the area of Westbrook Road. (Courtesy FOLPI.)

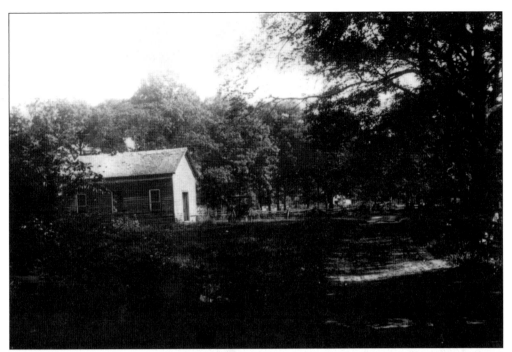

This original schoolhouse served the village of Hewitt at Long Pond Ironworks. It was located on Long House Road. (Courtesy the Louise Terhune Collection, FOLPI.)

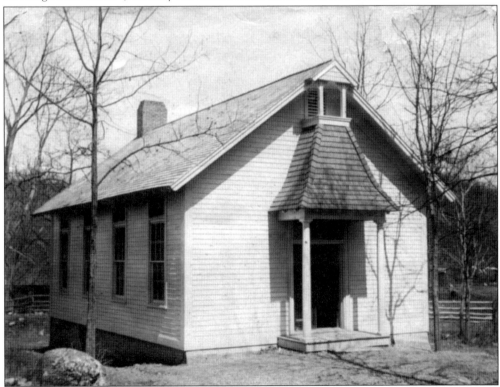

This is the second schoolhouse at Hewitt. (Courtesy FOLPI.)

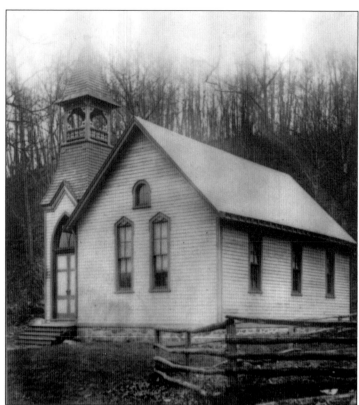

The Hewitt Methodist Church was built in 1895 on land donated by Abram Hewitt. The building still stands on Greenwood Lake Turnpike. (Courtesy the Louise Terhune Collection, FOLPI.)

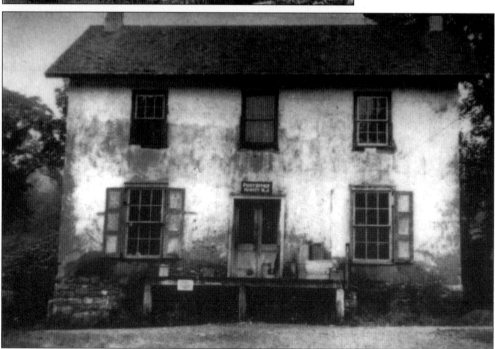

The Company Store at Long Pond Ironworks was located in the center of the village. It served as the ironworks office, general store, and post office. (Courtesy FOLPI.)

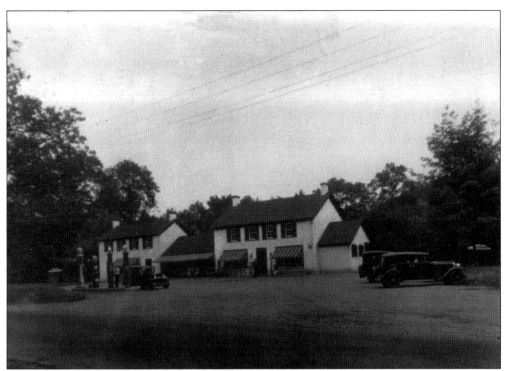

Both wings of the Old Country Store on Greenwood Lake Turnpike still stand as the main visitor center structures at the Long Pond Ironworks historical site. Tours of the extant structures and furnace remains are available by contacting the center. (Courtesy FOLPI.)

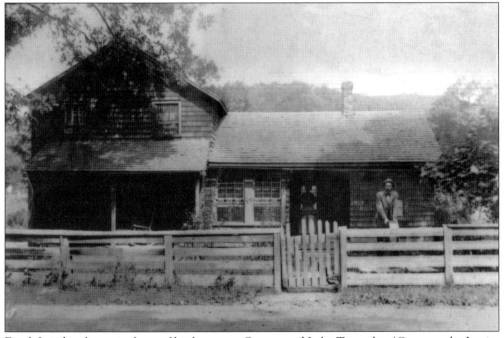

Frank Laird is shown in front of his house on Greenwood Lake Turnpike. (Courtesy the Louise Terhune Collection, FOLPI.)

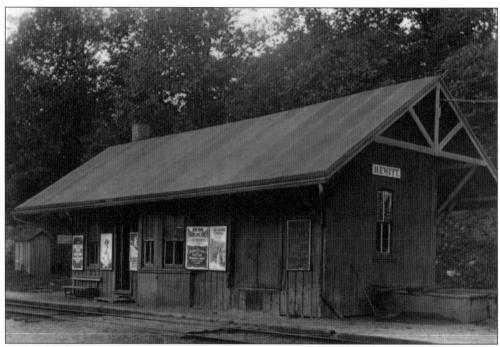

The Hewitt Station was in operation from the 1870s until the 1930s. (Courtesy the New Jersey Midland Railroad Historical Society Collection, FOLPI.)

The Laird-West House, on Greenwood Lake Turnpike, may have been constructed in 1810. This photograph was taken in the early 1900s. (Courtesy the Louise Terhune Collection, FOLPI.)

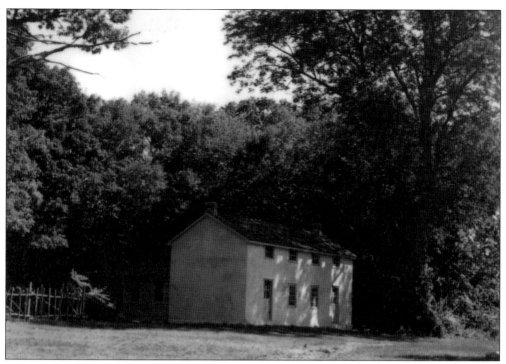

The Harty-Milligan House is thought to have been built in the 1850s or 1860s as a home for two workers and their families. (Courtesy the Beth T. Timsak Collection, FOLPI.)

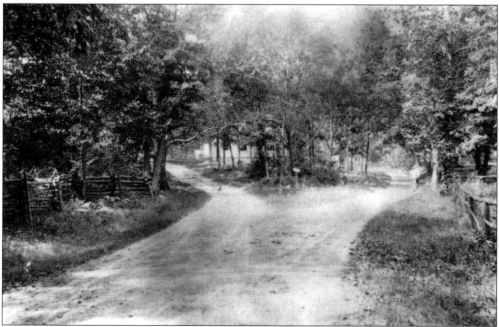

When the ironworks were operational, Greenwood Lake Road was just a dirt path and Furnace Road was a main thoroughfare. Today, the status of the roads is just the opposite. In the middle of the intersection is the second Hewitt schoolhouse. (Courtesy the Louise Terhune Collection, FOLPI.)

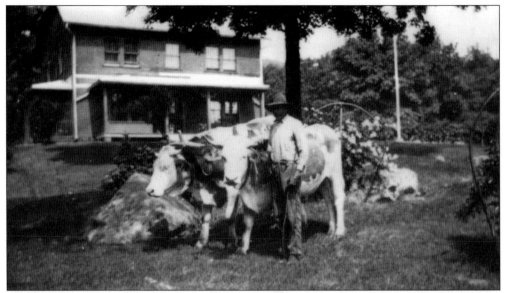

Ironworks manager Charles Stites and his oxen are on the lawn of his home. Oxen were indispensable for hauling materials over the hilly and rocky local terrain. (Courtesy the Louise Terhune Collection, FOLPI.)

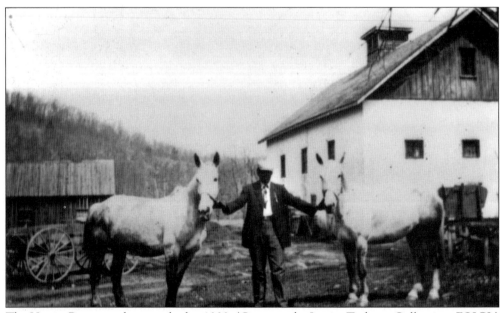

The Hewitt Barn was photographed c. 1900. (Courtesy the Louise Terhune Collection, FOLPI.)

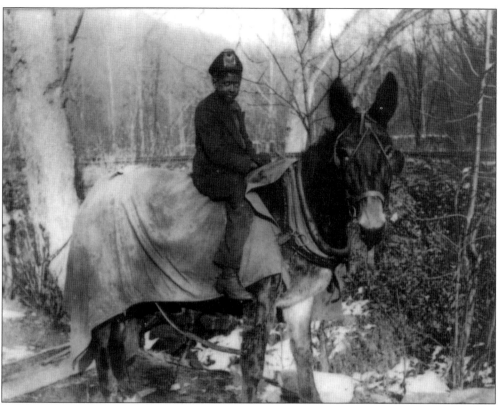

Surefooted mules were used to transport small loads around the rough, rocky Hewitt landscape. (Courtesy FOLPI.)

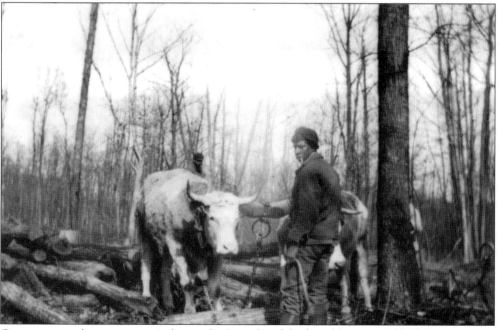

Oxen were used to transport timber at the Long Pond facility. (Courtesy FOLPI.)

Two women enjoy a pleasant drive in 1915 along Greenwood Lake Turnpike. (Courtesy the Louise Terhune Collection, FOLPI.)

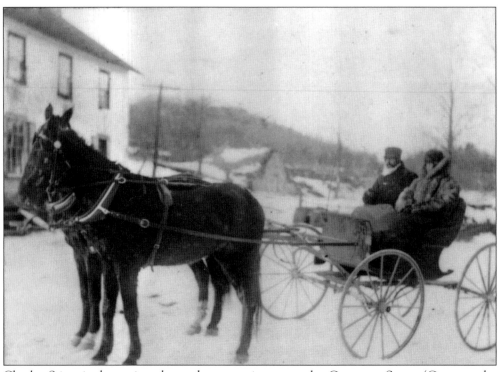

Charles Stites is shown in a horse-drawn carriage near the Company Store. (Courtesy the Louise Terhune Collection, FOLPI.)

Two

THE "VILLAGE"
OF WEST MILFORD

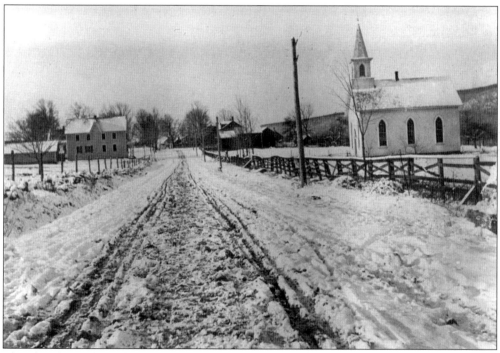

The church on the right in this photograph of Union Valley Road is now the West Milford Museum. The building on the left is the JR OUAM Hall. Today, the town hall is located just across the street from the museum.

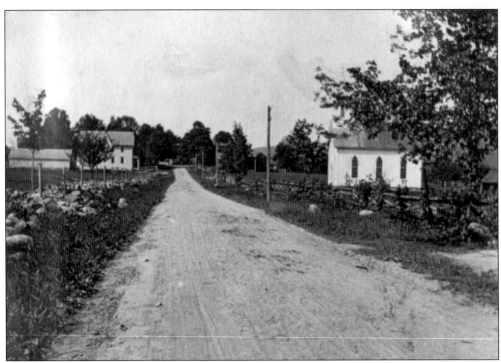

This view of Union Valley Road and the town center in the springtime looks south toward the junction with Macopin Road.

This more modern view looks north toward the junction with Marshall Hill Road. The museum building is on the right. The building on the left still stands and is home to a nail salon and a bagel shop.

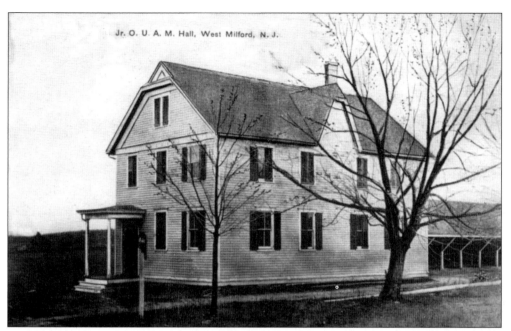

The JR OUAM Hall, located on Union Valley Road in the town center, still stands today.

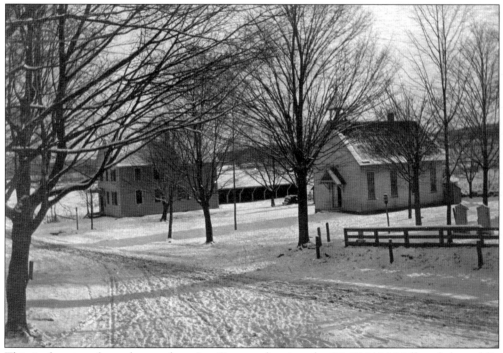

This is the view from the porch at Ivy Center, showing the JR OUAM Hall and the public school. The photograph was taken on December 18, 1906.

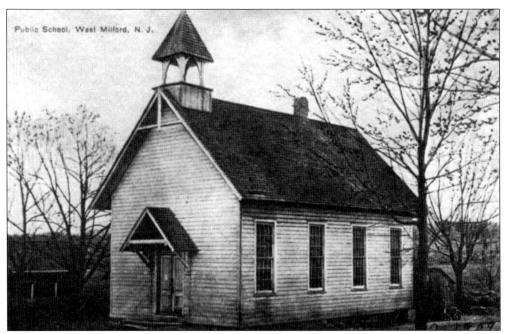

The West Milford Public School, located on Union Valley Road in the town center, still stands today.

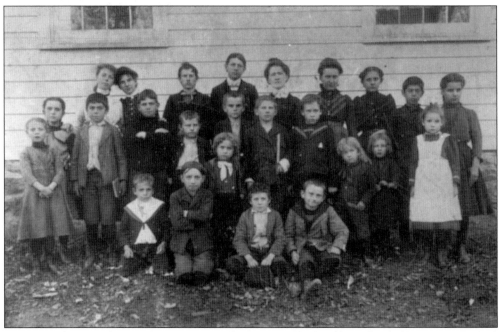

This class photograph was taken *c.* 1899 at the West Milford Public School. (Courtesy WMM.)

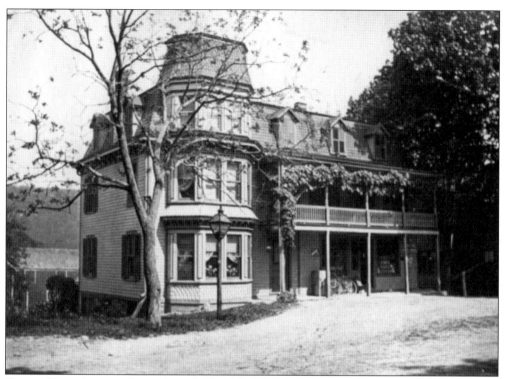

George Thorn's store, located in the town center on Union Valley Road across from the Presbyterian church, was called Ivy Center by local residents.

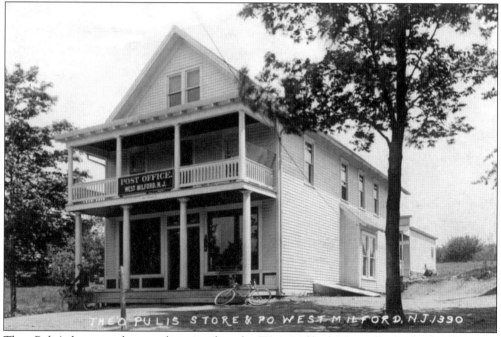

THEO PULIS STORE & P.O. WEST MILFORD, N.J. 1890

Theo Polis's home and store also served as the West Milford Post Office. This building still stands, but without its front porch. (Courtesy NJHHS.)

In this picture taken at the town center, the AME church (built c. 1860) can be seen in the background. The building later served as the West Milford Town Hall Annex and is now the West Milford Museum. (Courtesy WMM.)

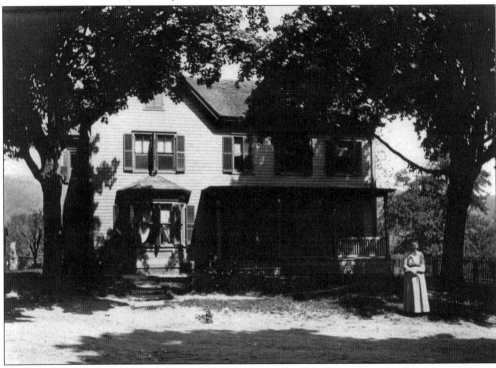

Maplehurst, the Hopper family home, is shown on May 21, 1906. Mrs. Hopper is standing on the right.

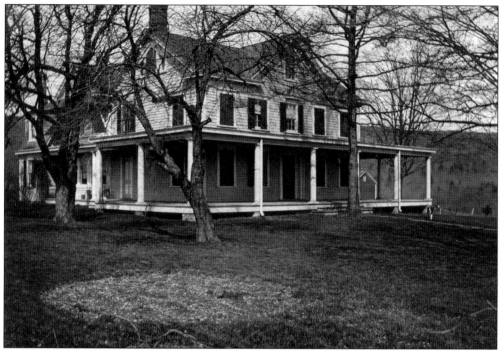

Notch Brook Farm was the summer home of John J. Voorhees. The photograph was taken on April 8, 1913.

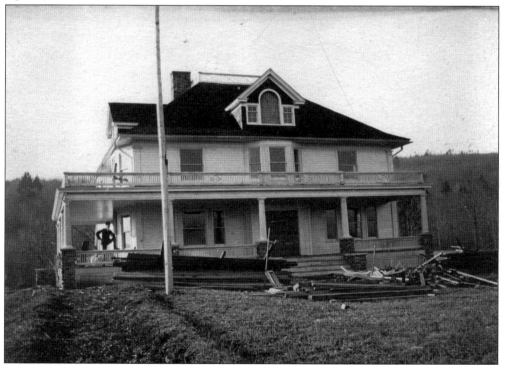

Buena Vista, the Warner house, was under construction in 1905. The house cost approximately $12,000 to build and was considered a mansion.

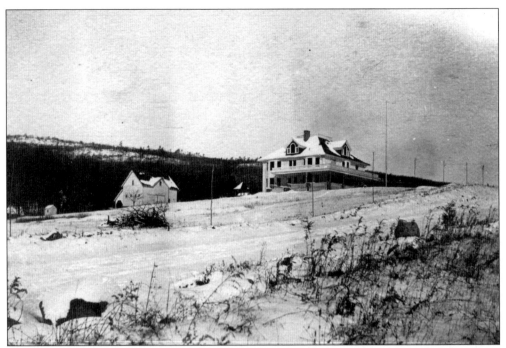

Another January 1906 photograph of Buena Vista includes A.J. Warner's farmhouse in the distance.

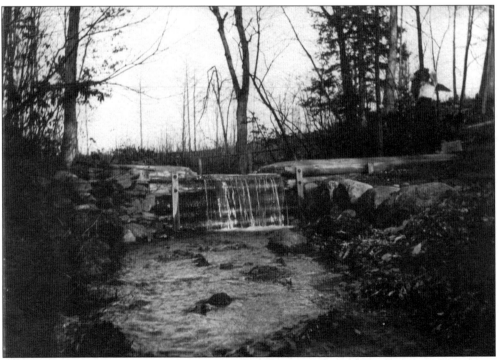

A close look at this view of the falls on the Buena Vista property reveals Mildred Brower atop of the dam on the right.

James A. Moody's house was photographed on December 14, 1905, by Gertrude Terhune, who noted that the house was later sold to "Egbert, a city man."

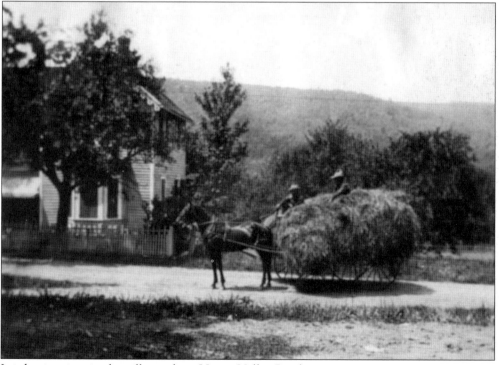

It is haying time in the village, along Union Valley Road.

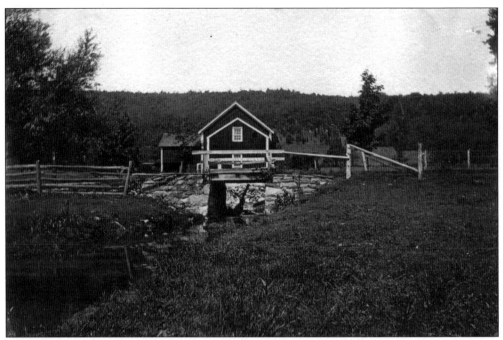

The bridge and stream at Brookdale were photographed in August 1906. The photograph was taken from Brookdale, with the Manchee barn across the street. Union Valley Road runs across the bridge, and West Mountain is in the background.

This early-1900s photograph shows the Leake house on Union Valley Road.

This photograph was taken at the junction of the Mill Road and Warwick Road (now White Road and Warwick Turnpike), facing Warwick and Greenwood (Moe) Mountain. White's sawmill would have been off to the right.

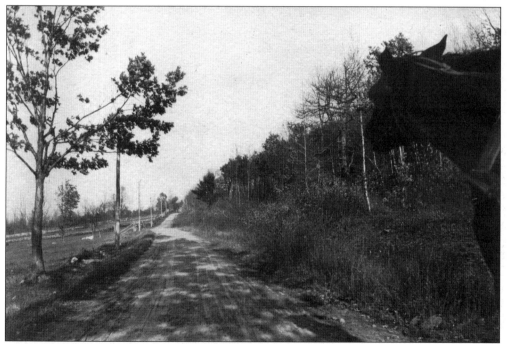

This photograph was taken near the junction of Union Valley and Mill Roads in November 1905. It shows Union Valley Road heading back to the village. Mill Road is known today as White Road, after John White, who ran the sawmill.

This view shows Union Valley Road heading toward the town center, with Brookdale on the left and the Manchee barn on the right.

Brookdale is on the right and the Manchee property on the left in this April 17, 1913 view of Union Valley Road.

Brookdale was photographed on March 29, 1913, from Union Valley Road.

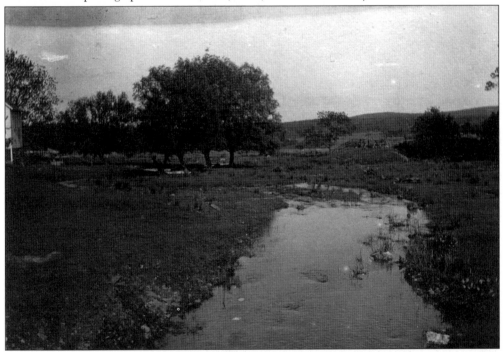

The Terhune family created this little pond by the willows at Brookdale by diverting water from the brook; it was often frequented by the Manchee family's geese. This photograph was taken on May 29, 1906.

Ed Latta and other members of the West Milford baseball team play a game in August 1905.

Shown in 1905, Wilfrid A. Manchee was a neighbor to the Terhunes and the captain of the West Milford baseball team.

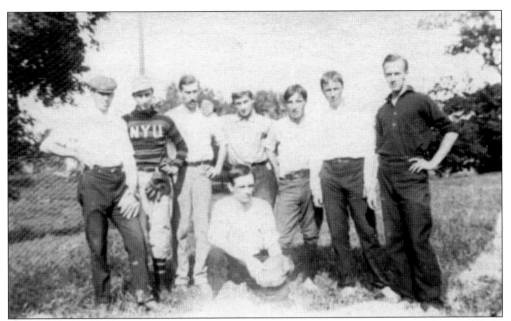

Members of the 1905 West Milford baseball team included Harry Thorn, Stanley Manchee, Bob Hutton, Leonard Terhune, Walter Terhune, Wilfred A. Manchee, Gilbert Tehune, and (sitting) Austin Wheeler Thompson.

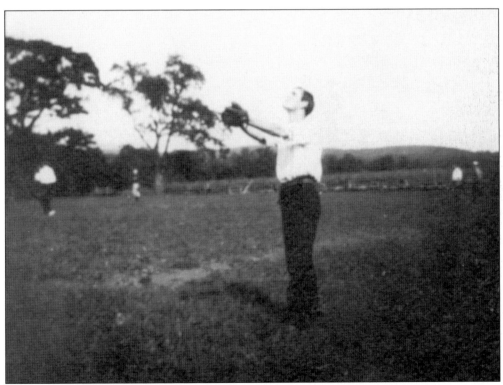

Austin Wheeler Thompson catches a fly ball at the Brookdale Diamond in 1905.

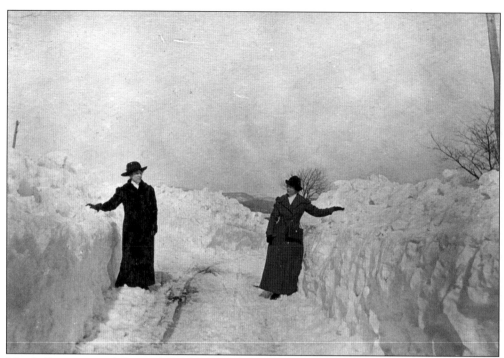

Maude Francisco and Gertrude Terhune stand in front of Power's Corner on March 12, 1914.

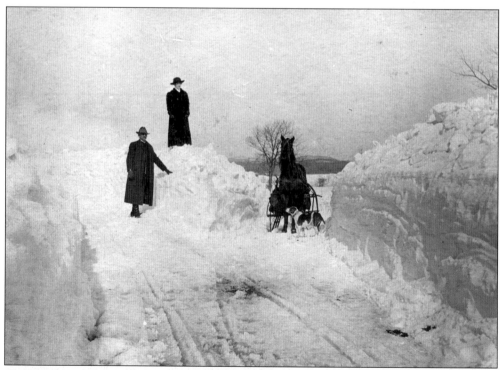

"Pop" Terhune, Maude Francisco, Maude the horse, and Billy the dog try to negotiate "the cut" at Power's Corner, 10 days after the blizzard of March 1–2, 1914.

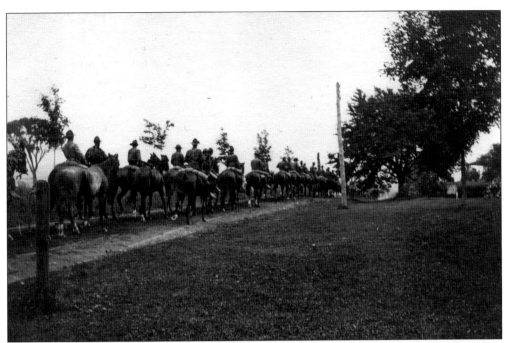

The First Squadron of New Jersey marches through West Milford on June 20, 1913. Nearly 200 soldiers had camped at Waywayanda Lake and were en route to Newark. This photograph was taken along Union Valley Road in front of the Manchee house.

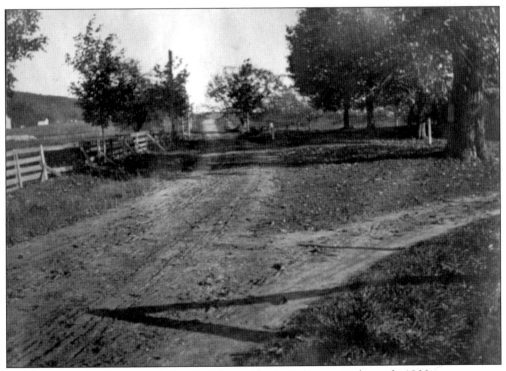

This is a scene along Union Valley Road near the town center in the early 1900s.

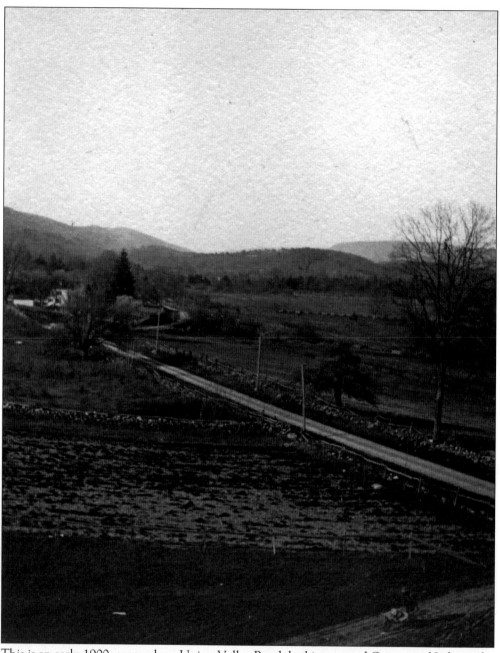

This is an early-1900s scene along Union Valley Road, looking toward Greenwood Lake in the distance. Note the farmer and the wheelbarrow in the foreground.

Three

PINECLIFF LAKE AND GREENWOOD LAKE

An early-1900s postcard shows Pinecliff Lake, with a portion of Bearfort Mountain to the right. Pinecliff Lake and Bearfort Mountain have long been among West Milford's most scenic vistas, memorialized by many artists, including internationally renowned painter Jasper F. Cropsey. (Courtesy WMM.)

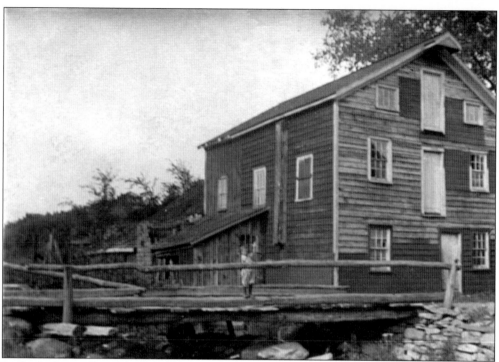

La Roe's Gristmill and bridge at Stowaway Park was in operation from the mid-1800s until a flood in 1908. The flood destroyed the dam and disabled the waterwheel, which provided power for turning the milling stones. (Courtesy NJHHS.)

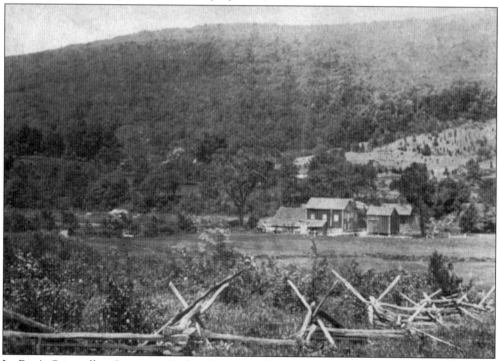

La Roe's Gristmill at Stowaway Park is shown amidst pastoral farmlands. (Courtesy WMM.)

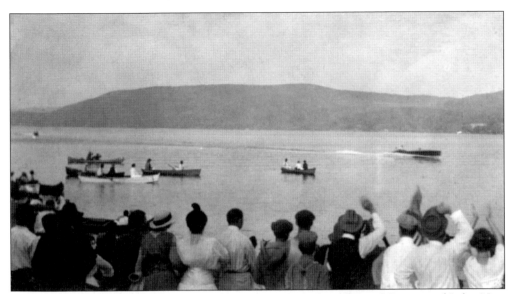

Nine-mile-long Greenwood Lake extends to Hewitt from the village of Greenwood Lake, New York. It has a long history of hosting boat races like this early regatta. In recent years, it has upgraded to hosting powerboat classics. (Courtesy NJHHS.)

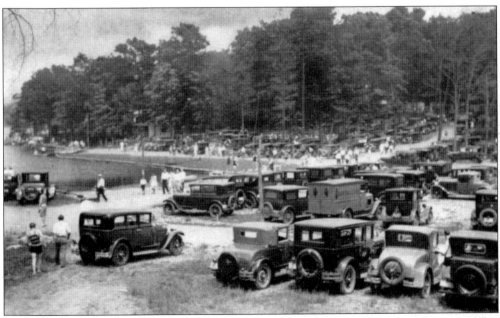

Greenwood Lake has long been a popular tourist destination for visitors from the cities. This postcard shows a crowded parking lot in the early 1900s.

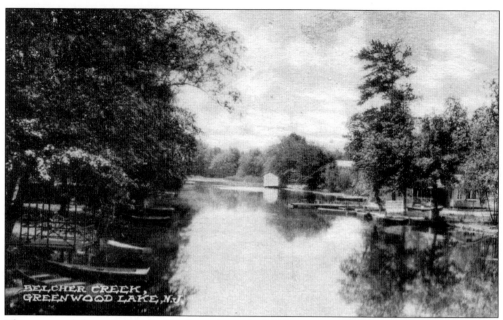

This postcard shows Belcher's Creek in the early 1900s.

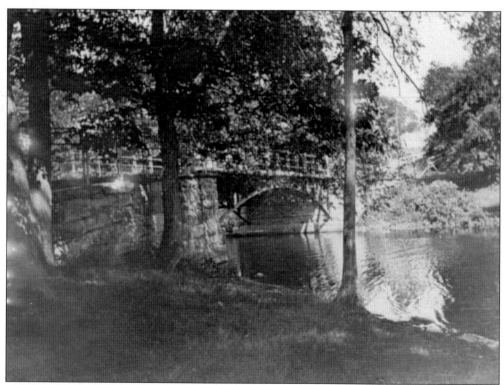

This tranquil view shows the bridge over Belcher's Creek prior to 1910. (Courtesy WMM.)

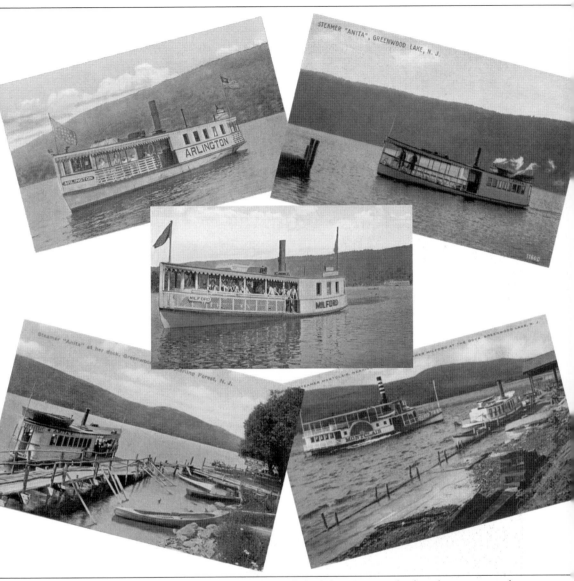

Pleasure boats were used to guide sightseers around the lake. Among the best known were the *Anita*, the *Arlington*, the *Milford*, and the *Montclair*.

The Mountain Ice Company of Hoboken operated ice-cutting facilities at Greenwood Lake. Ice cutting on the West Milford lakes was a major industry in the late 1800s; the icehouse at Echo Lake was reputed to have shipped 20,000 tons of ice in one year. (Courtesy NJHHS.)

A train arrives at Greenwood Lake Station. Trains from Manhattan and large New Jersey cities brought numerous tourists to West Milford's lakes and resorts during the late 1800s and early 1900s. (Courtesy NJHHS.)

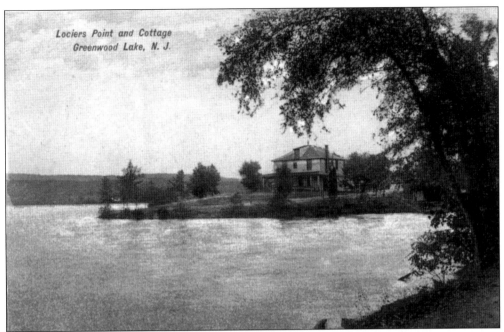

Lociers Point and cottage are on Greenwood Lake in West Milford (Hewitt).

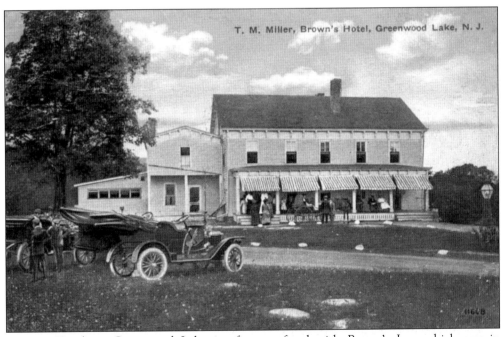

Brown's Hotel on Greenwood Lake is often confused with Brown's Inn, which was in Newfoundland. (See page 67.)

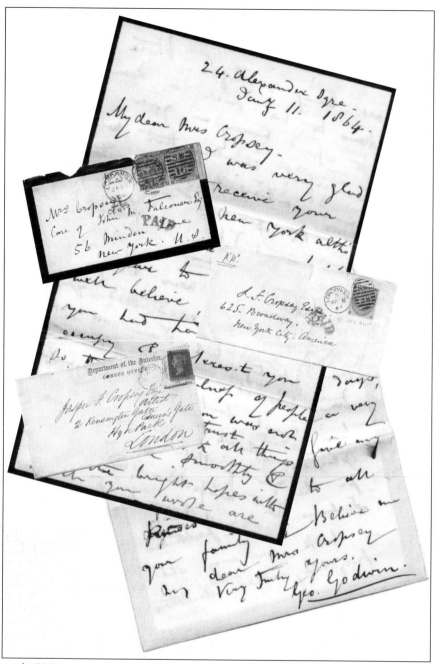

In the mid-1800s, painter Jasper F. Cropsey came to West Milford for relaxation. Here, he met West Milford resident Maria Cooley, whom he later married. Cropsey went on to paint in Europe and became known as the premier Hudson River School artist. These correspondence sheets come from a letter written to Maria Cropsey, after the couple returned from London. The letter was written by famous London architect and author George Godwin. It discusses events such as the latest London theater news, Godwin's newest book, Jasper Cropsey's illness, and the recent death of Godwin's father. The other letter covers show addresses where the Cropseys lived, including Kensington Gate in Hyde Park, London.

Four
ECHO LAKE, MACOPIN, POSTVILLE, AND CHARLOTTEBURG

Echo Lake has long been revered for its natural beauty and for boating. Today, visitors may still boat and fish on this pristine lake (non-gasoline boats only) with a permit from the Newark Watershed Conservation and Development Corporation (NWCDC). (Courtesy William Wurst.)

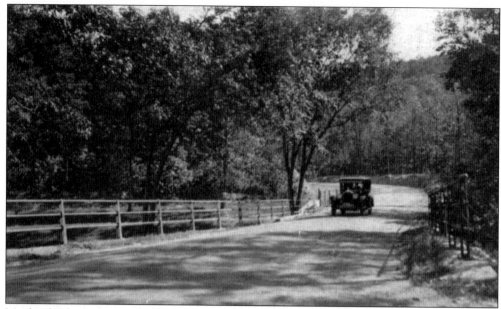

Much of Echo Lake Road still appears as it did in the days when this photograph was taken, although the vehicles certainly have changed. (Courtesy WMM.)

This photograph of Echo Lake was taken from Echo Lake Road. Today trees partially obstruct the view of the lake from the road, but the lake and lakeshore still remain virtually the same. (Courtesy WMM.)

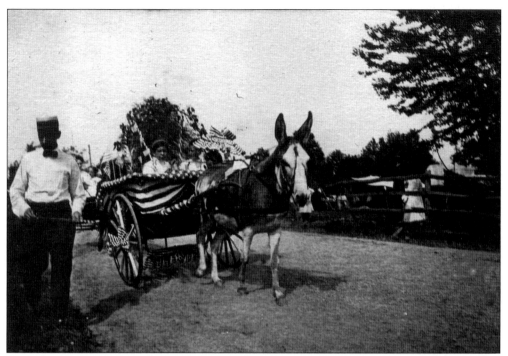

According to Gertrude Terhune, this cart took the top prize at the Donkey rig at the Old Boys Association carnival at Echo Lake on August 15, 1905.

The Newfoundland Band plays at the Old Boys Association carnival.

Echo Lake's picnic grounds were once freely open to the public. Today, visitors to the lake must have permission from the NWCDC. (Courtesy WMM.)

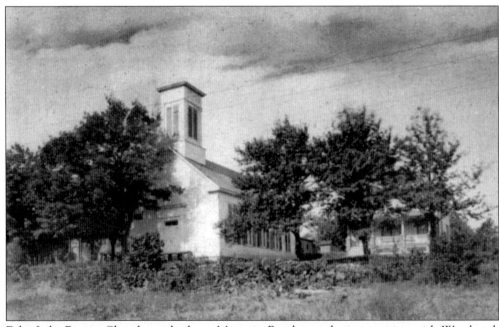

Echo Lake Baptist Church was built on Macopin Road near the intersection with Westbrook Road. The church was organized on June 30, 1874, by Rev. Conrad Vreeland with 12 parishioners and still stands today. (Courtesy WMM.)

St. Joseph's Church is on Germantown Road. (Courtesy WMM.)

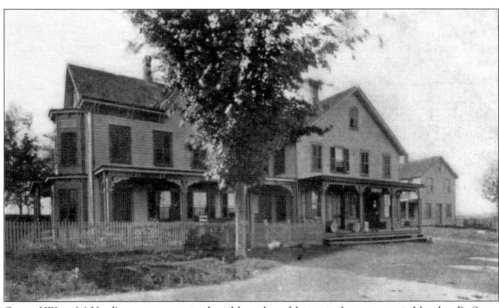

One of West Milford's most-recognized and best-loved historical structures is Vreeland's Store and Post Office, located on Macopin Road across from the intersection with Westbrook Road. It is shown here c. 1906. (Courtesy WMM.)

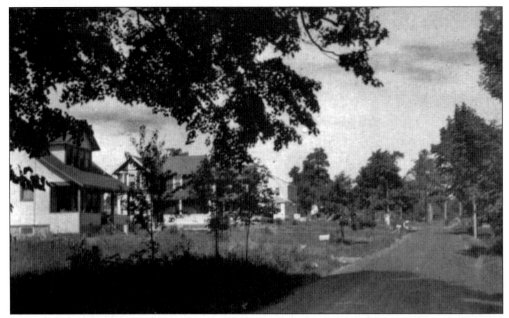

Many of these homes on Macopin Road near the intersection with Highlander Drive still stand. (Courtesy WMM.)

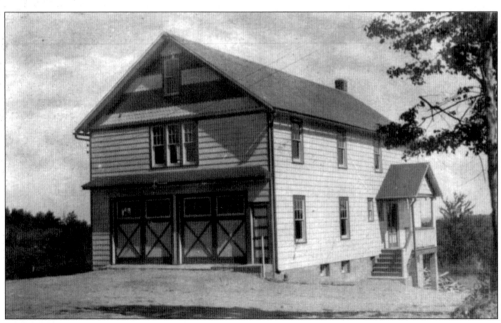

The firehouse on Macopin Road, near Westbrook Road, was knocked down in the late 1990s after attempts to find a new tenant to renovate and occupy it failed. (Courtesy WMM.)

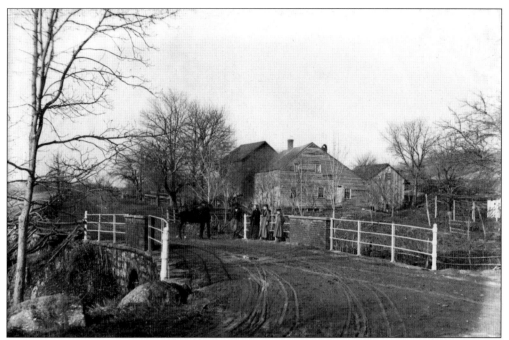

A family stands at the edge of their farm at the intersection of Union Valley Road and Gould Road, in what was known as Postville. The foundation of the bridge still stands today. (Courtesy NJHHS.)

The schoolhouse at Postville was located near the intersection of Union Valley Road and Oxbow Lane. (Courtesy NJHHS.)

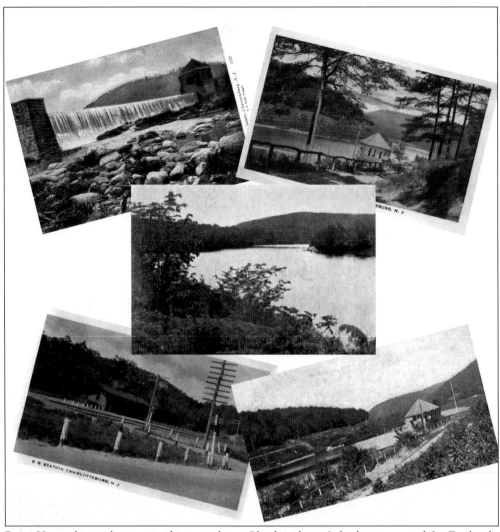

Peter Hasenclever also operated ironworks at Charlotteburg (which was named for England's Queen Charlotte, wife of George III). Charlotteburg developed into a large town of several hundred residents, but the town was evacuated and flooded in the decades after the furnace shut down. These postcards show the reservoir where the train station in town once stood and the intake below the reservoir between the north and south lanes of Route 23. The pump building on the right was recently restored to its original beauty. (Courtesy William Wurst and NJHHS.)

Five

OAK RIDGE AND
NEWFOUNDLAND

Oak Ridge Reservoir is shown *c.* 1900. (Courtesy NJHHS.)

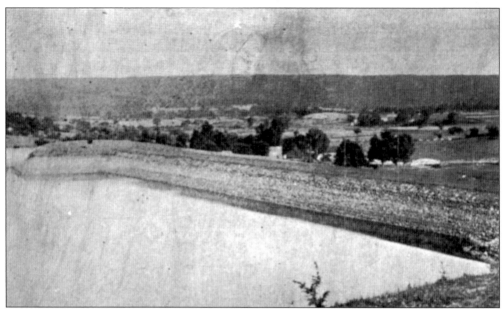

This view of Oak Ridge Reservoir shows farmlands in the background. (Courtesy Harry Rescigno.)

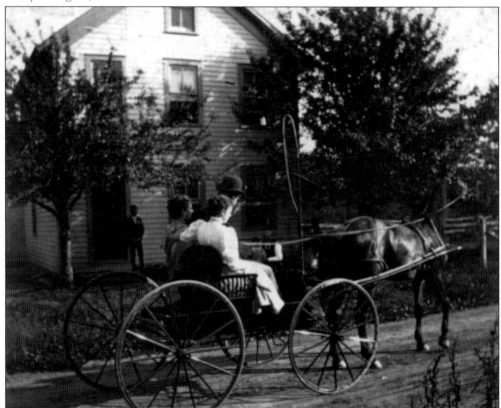

This horse-drawn cart was photographed outside the McConnell residence in Oak Ridge in the early 1900s. (Courtesy NJHHS.)

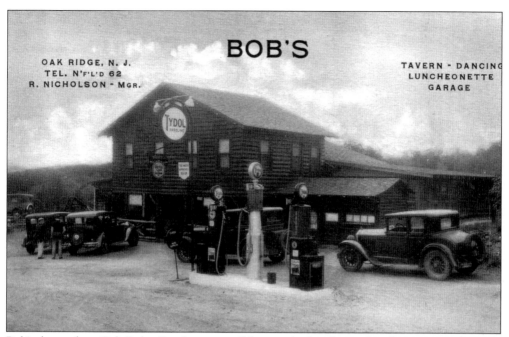

Bob's, located on Oak Ridge Road, was a well-known facility for weekend parties and dancing. It also served as a luncheonette and gas station during the day. (Courtesy WMM.)

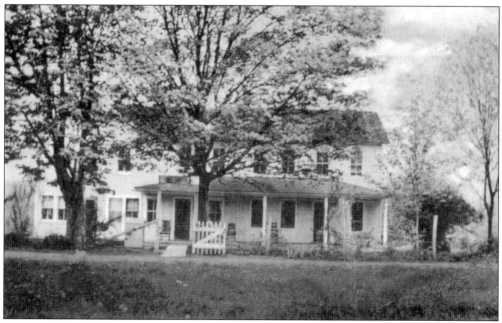

Webb's Homestead, an idyllic farmhouse in Newfoundland, is shown here *c.* 1905. (Courtesy WMM.)

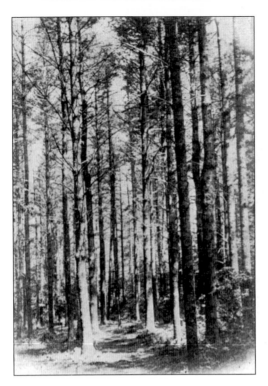

This dramatic shot shows the tall pines in Newfoundland. Pines like these still exist in Newfoundland, in the area of Kanouse mountain, although it is not known if that was where this photograph was taken.

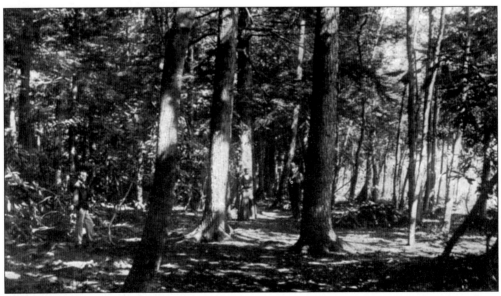

Careful inspection of this early-1900s scene in a Newfoundland grove reveals three people in the background.

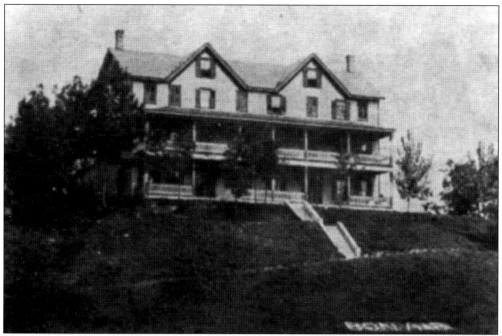

The Hotel Bon Air was one of Newfoundland's resorts that operated *c*. 1905, when this photograph for an advertisement was taken.

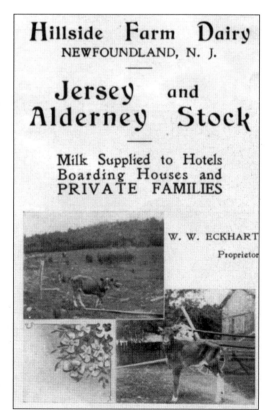

Hillside Farm Dairy
NEWFOUNDLAND, N. J.

Jersey and
Alderney Stock

Milk Supplied to Hotels
Boarding Houses and
PRIVATE FAMILIES

W. W. ECKHART
Proprietor

An advertisement for the Hillside Farm Dairy in Newfoundland demonstrates Newfoundland's pastoral history.

This residence on Main Street in Newfoundland, pictured *c.* 1900, was later used for a drugstore.

J.F. Gleason and a friend pose in front of the Gleason home in Newfoundland.

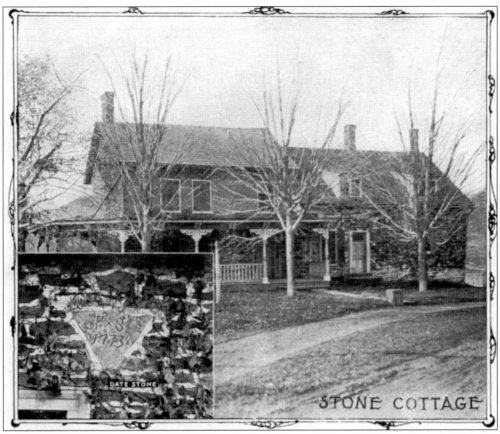

STONE COTTAGE

DATE STONE

The Old Stone Cottage was located in an area of Newfoundland along Green Pond Road that is part of Jefferson Township. This home was built by a French Huguenot family in 1732 and was enlarged in 1773. Still standing on property owned by the City of Newark, it may be the oldest home in the area.

These marchers take part in an August 14, 1909 parade.

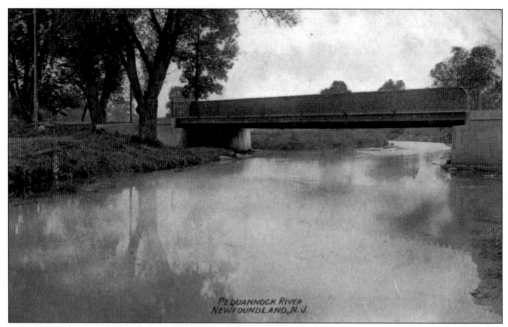

This bridge over the Pequannock River in Newfoundland, shown c. 1905, was part of historical Main Street in Newfoundland. (Courtesy Harry Rescigno.)

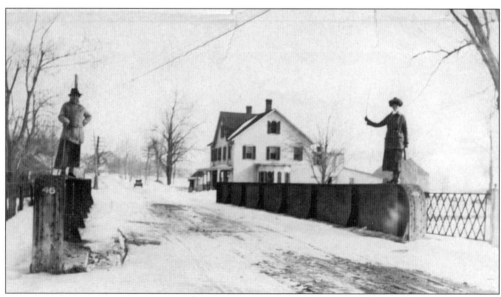

Two women proudly display their balancing skills atop Newfoundland's Pequannock River bridge in February 1920. (Courtesy WMM.)

This winter scene in Newfoundland was used to publicize the area's natural beauty for tourism.

The Pequannock River in Newfoundland is framed by bucolic farms and fences.

Newfoundland and the surrounding region is known for its apple orchards, as shown by this splendid example of an apple tree in blossom.

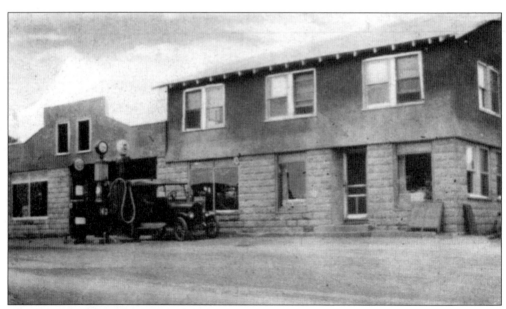

Hopper's Garage and Tea Room was located in Newfoundland on Old Route 23. (Courtesy Harry Rescigno.)

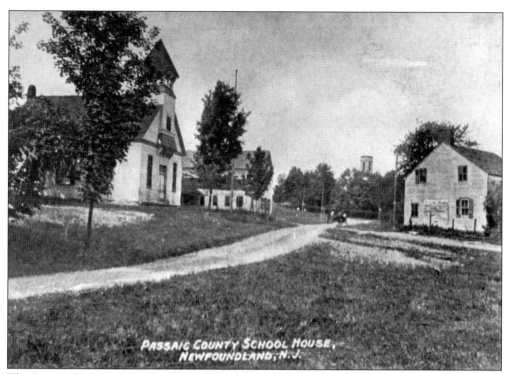

The Passaic County Schoolhouse is on the left of this photograph, taken at the intersection of Clinton Road and Route 23. (Courtesy NJHHS.)

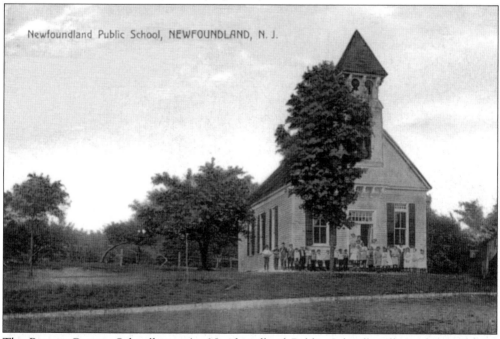

The Passaic County Schoolhouse (or Newfoundland Public School) still stands on Clinton Road, on the median between the north and south lanes of Route 23. The building has been expanded and is now the Village Square Inn. This image shows one of the school's classes.

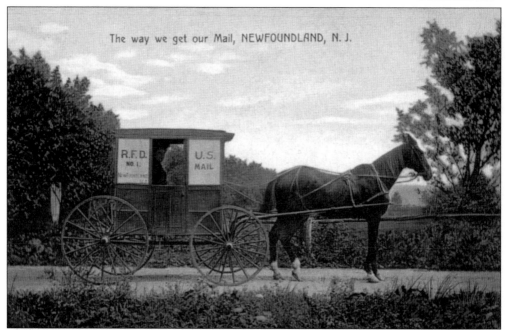

The way we get our Mail, NEWFOUNDLAND, N. J.

R.F.D. NO. 1.

U.S. MAIL

Luckily, the Newfoundland Post Office has modernized its equipment since this postcard was created in the early 1900s. (Courtesy William Wurst.)

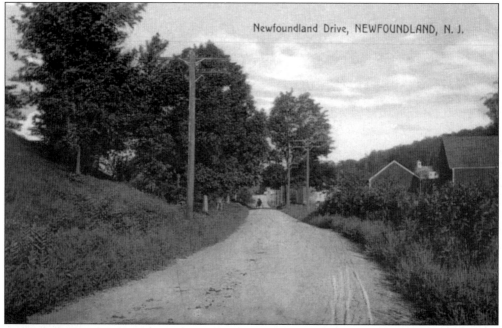

Newfoundland Drive, NEWFOUNDLAND, N. J.

Newfoundland was known for its scenic drives, as this c. 1900 postcard illustrates.

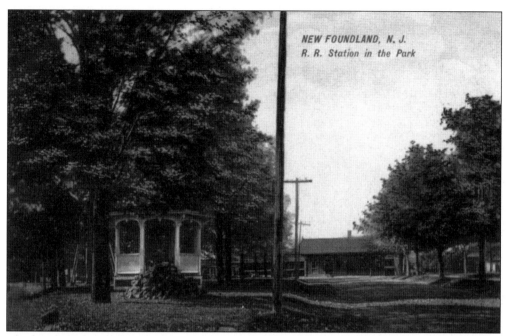

The bandstand and the Newfoundland Station were once connected with Brown's Inn. Both are still standing and have been recently restored.

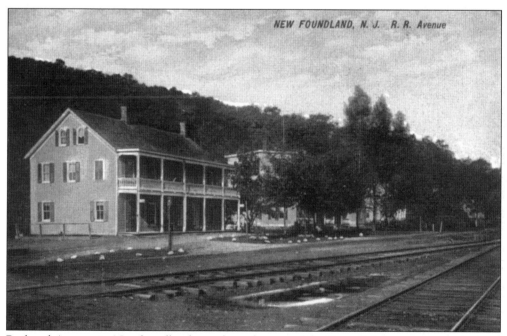

Railroad Avenue in Newfoundland ran along the rear of the Brown's Inn property.

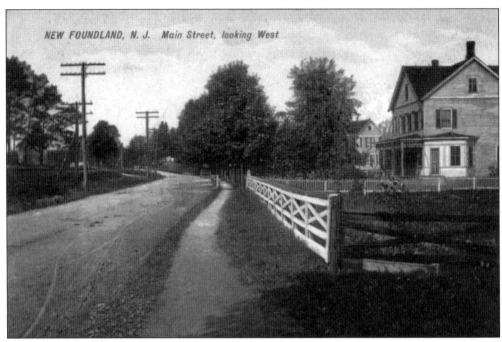

Main Street in Newfoundland is shown in this view looking west.

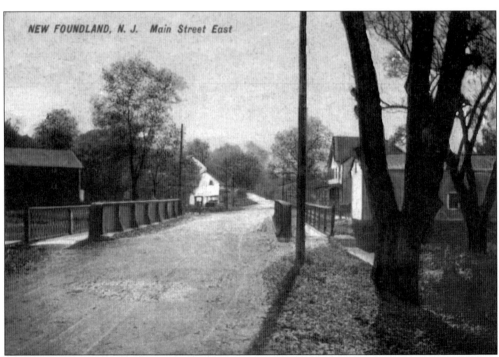

A view of Main Street in Newfoundland, looking east, shows the bridge over the Pequannock River.

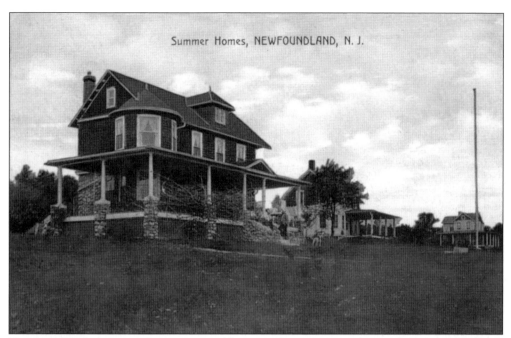

Summer Homes, NEWFOUNDLAND, N. J.

Newfoundland was a popular recreational location for summer visitors and residents who built summer homes in the area.

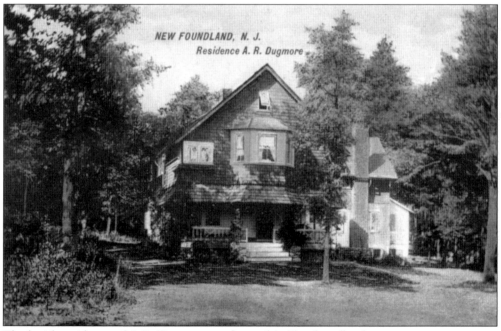

NEW FOUNDLAND, N. J.
Residence A. R. Dugmore

The lavish residence of A.R. Dugmore was located in Newfoundland.

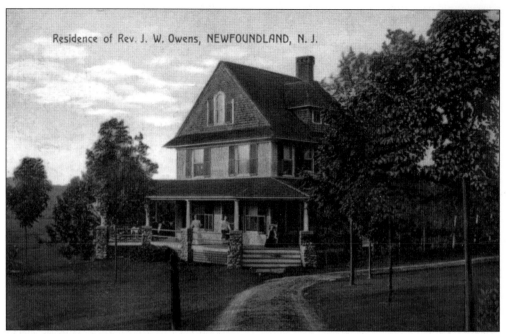

This postcard shows a Newfoundland farm along the banks of the Pequannock River.

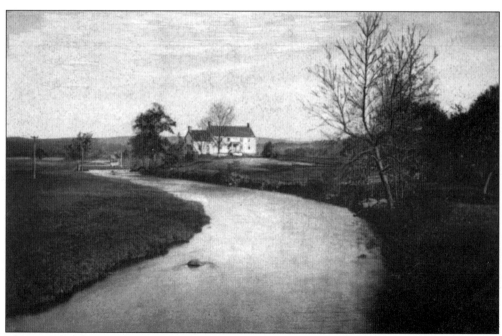

This postcard shows country-style Newfoundland homes.

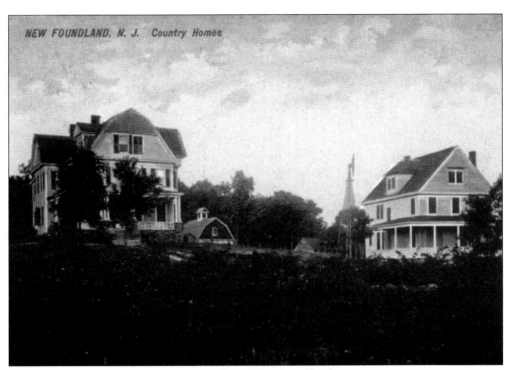

The residence of Rev. J.W. Owens was also in Newfoundland.

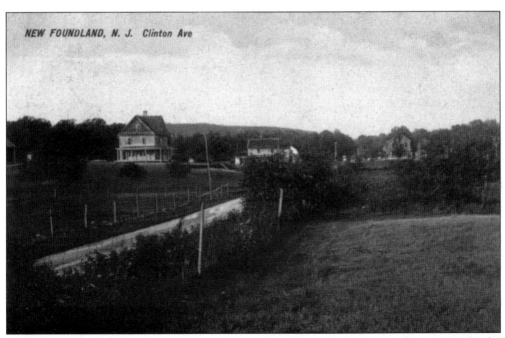

Homes along the end of Clinton Avenue (Clinton Road) are no longer standing, except for the one on the far left.

VanHorn's shop was in the Greenleaf Park section of Newfoundland.

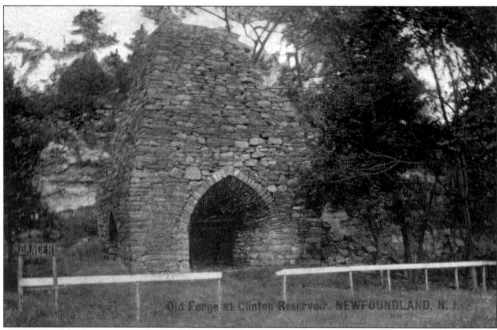

The ironworks at the Clinton Furnace, shown in the early 20th century, operated from 1826 until 1837. The ironworks were abandoned due to the high cost of transporting necessary materials. (Courtesy William Wurst.)

The Clinton Furnace was constructed of native stone and measured 29 feet by 29 feet at its base, tapering to 18 feet by 18 feet at the top.

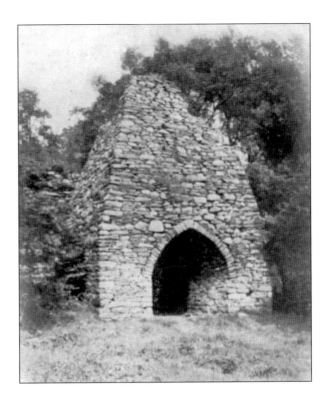

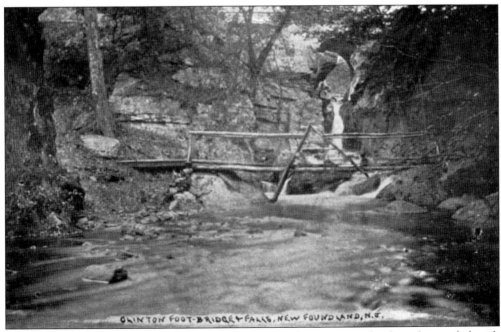

Clinton Falls were useful for powering the furnace. The area was also heavily wooded with maple, oak, hickory, and chestnut. (Courtesy William Wurst.)

The village of Clinton had a somewhat dubious reputation. According to local period historian J.P. Crayon, the woods near Newfoundland were thought to be infested with robbers, who would hide in the gorges near Clinton for shelter, their noises deadened by the sound of the falls.

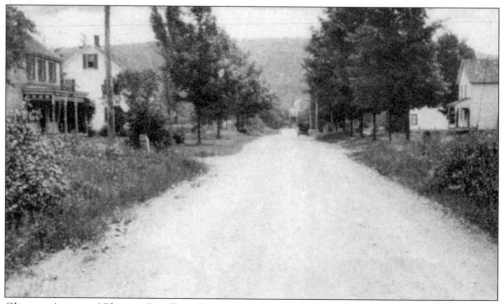

Clinton Avenue (Clinton Road) is shown as it approaches what is now Route 23. Many of these homes are still standing today. (Courtesy WMM.)

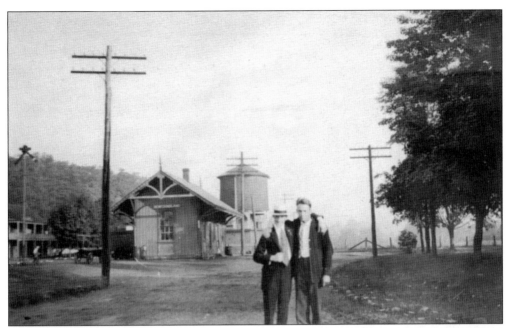

Two friends enjoy a summer afternoon, perhaps after arriving by train at the Newfoundland Station. (Courtesy WMM.)

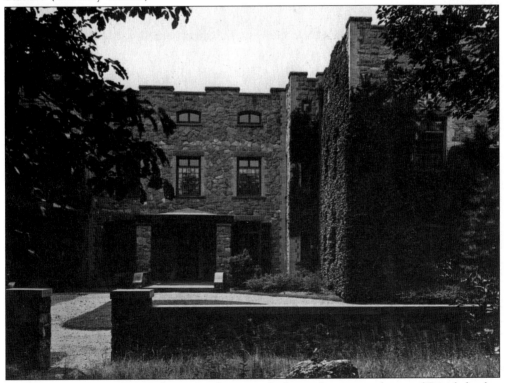

Bearfort House (or Cross Castle, as it is known today) was the country home of British banker Richard James Cross. The castle was built at the start of the 20th century on a 442-acre estate. The extensive property included acres of forest, fields, farmlands, and Hank's Pond. (Courtesy WMM.)

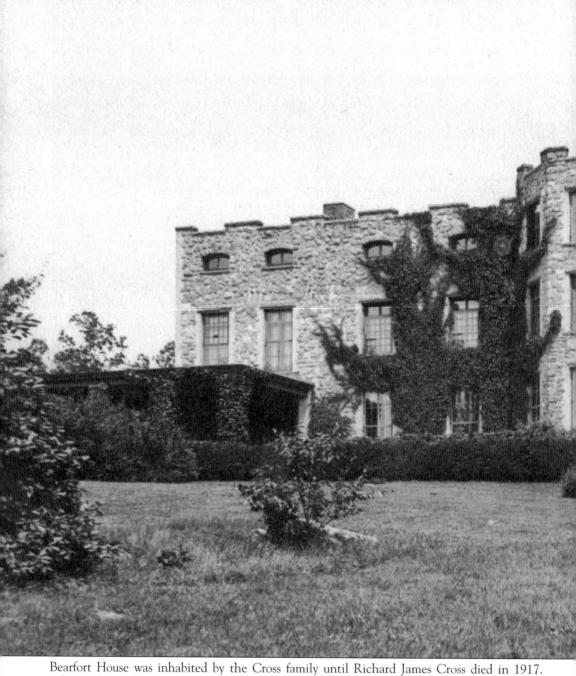

Bearfort House was inhabited by the Cross family until Richard James Cross died in 1917. Afterward, the family vacated the estate, finally selling it in 1919 to the City of Newark. Considering that the estimated cost of constructing the main house alone is estimated to have been approximately $1.5 million, the entire estate was sold for only a fraction of its value—a mere $150,000. The new owner stripped the main house of all items of value and sold them at auction. Many Newfoundland, Oak Ridge, and Jefferson homes incorporated items from Cross

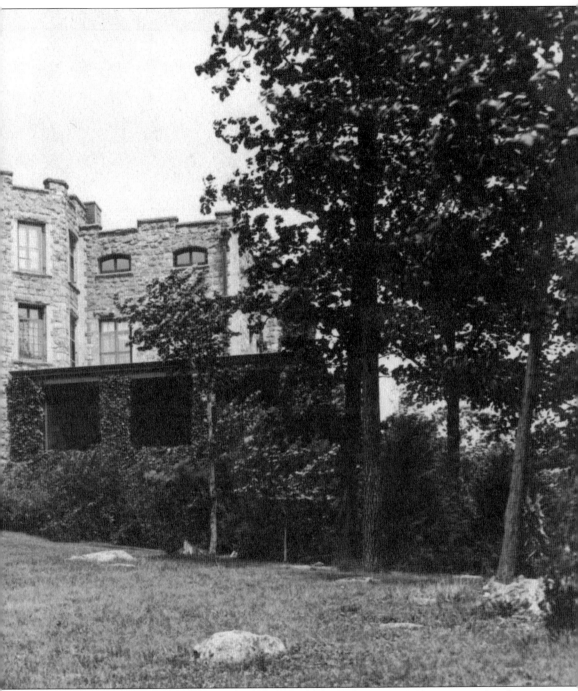

Castle into their structures, including floor beams, wooden stairs, bathroom fixtures, fireplace mantels, paneling, and slate roofing tiles. The thick stone walls remained as the area's only gothic ruin for decades, with many stones and ledges removed by pillagers over time. Finally, the City of Newark razed the walls in the late 1980s, just as the castle site had been proposed for historical designation. (Courtesy WMM.)

Cross Castle was built on a high rock ledge, which offered views of the unspoiled countryside for miles in each direction. (Courtesy WMM.)

Bearfort House was constructed by local stonemasons entirely of native stone. An area was blasted out of the stone ledge upon which the foundation was built, allowing for the creation of a cellar to run underneath the entire structure. The walls rose to a grand height of 50 feet and were between 3 and 4 feet thick at the base. (Courtesy WMM.)

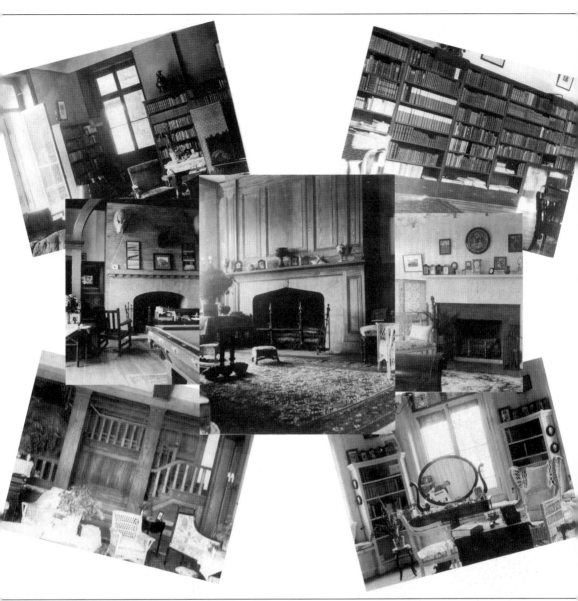

The interior of Cross Castle reflected the British heritage and style of its owners. The Cross family paid particular attention to the library, as a reflection of their awareness of literature and the value of education. They assisted in organizing the Newfoundland Village Improvement Society and worked on a proposal to combine the Passaic and Morris County Schools to provide uniform grading standards for scholars. The family also played an integral role in arranging an educational lecture series at the Newfoundland Methodist Episcopal Church. They shared the love of books, reflected in their personal library, with the Newfoundland community. They worked to establish a public library in Newfoundland and reportedly personally approved each volume before its addition to the library shelves. (Courtesy WMM.)

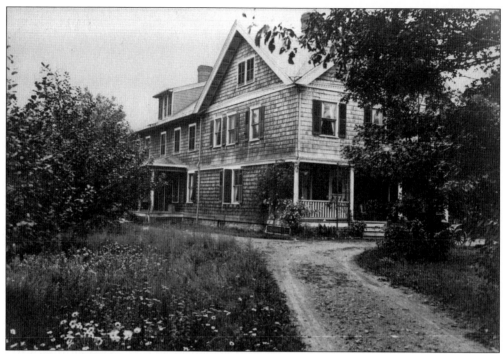

The estate included guesthouses like this one. (Courtesy WMM.)

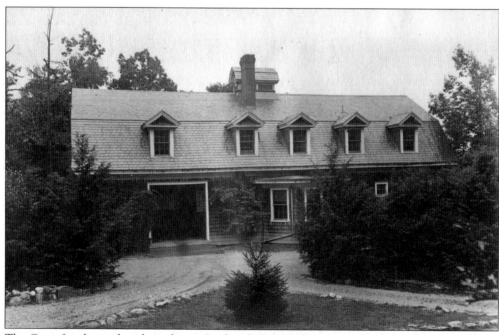

The Cross family employed coachman Dyckinck Campbell to drive them in an elegant carriage on local outings to the railroad station or to church. They were the first family in Newfoundland to own a gasoline-powered automobile. Not surprisingly, one of the family's accomplishments as part of the Newfoundland Village Improvement Society was making substantial improvements to Newfoundland's roads. (Courtesy WMM.)

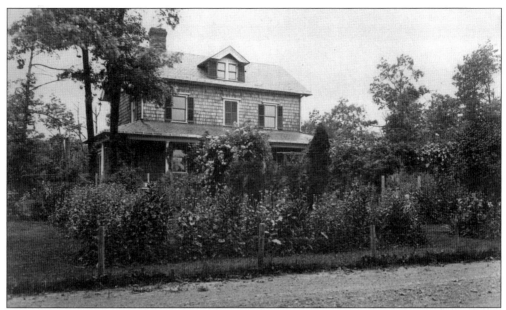

The Cross family was well accustomed to lavishly furnished living quarters, which included guest and servant quarters. The family's primary residence was a posh 6 Washington Square North address in Manhattan. Richard James had become a wildly successful banker at the firm of Morton, Bliss, & Company until he retired in 1899. After his retirement, he continued to participate in the financial services industry as the Manhattan Trust Company's director and as a trustee for the Atlas Insurance Company, the Palatine Insurance Company, and U.S. Doyd's. Cross maintained a vibrant social life in New York, where he was a member of the Century Club of New York and active in local tennis and racquet clubs. (Courtesy WMM.)

These are additional outbuildings on the Cross Estate. (Courtesy WMM.)

The Cross estate had many outbuildings. In addition to the system of indirect hot water heat for the main house, it had stately fireplaces that provided warmth during chilly weather. Although the fireplaces surely provided lighting in the evenings, the estate had a private gas plant on site for lighting. (Courtesy WMM.)

The Cross family enjoyed the luxury of hot and cold running water in Bearfort House. Local spring water was stored in a 25,000-gallon stone tower on the grounds and piped to the castle, its gardens, and outbuildings on the estate. (Courtesy WMM.)

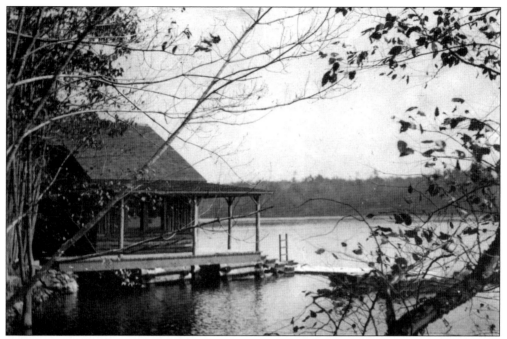

The estate was well equipped for outdoor activity. This photograph shows the boathouse on Hank's Pond. (Courtesy WMM.)

Hank's Pond must have provided a contrast to Liverpool, where Richard James Cross was born in 1845 to William and Anna Chalmers (Wood) Cross. He was educated at England's Marlborough College before deciding to seek his fortune in America. Cross first settled in New Orleans and later moved to New York. Richard James Cross met Matilda Redmond in New York, where they were married in 1872. Matilda bore Richard six children—Eleanor, Eliot Buchanan, Mary R., Emily R., W. Redmond, and John W. Cross. Sadly, Matilda did not live to see her children survive into adulthood. After Matilda's death, Richard James married her sister Annie Redmond. It was Annie Redmond Cross who raised Matilda's children and lived at Cross Castle. (Courtesy WMM.)

Hank's pond covered 77 acres of the Cross estate and is now part of the Newark Watershed, near Clinton Reservoir. Hank's Pond has been known by that name from the time of the earliest surveys of the area, conducted in the early 1800s. Historians have theorized that the name derived not from an early resident called Hank but evolved from the Native American name for one of the most common animal resident of the pond—the squirrel. The Native American word for squirrel is *hannick* (or *haniqus*), which lends itself to the notion that "Hannick's" pond evolved to Hank's pond over time. (Courtesy WMM.)

Six

IDYLEASE

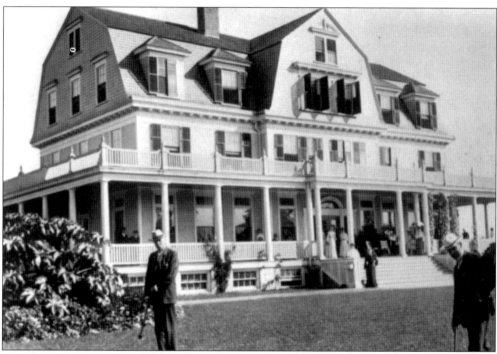

The Idylease Inn, on Union Valley Road in Newfoundland, was constructed in 1902 and was opened in 1903 by Dr. Edgar A. Day. Day had moved to Newfoundland to improve his health. He promoted Idylease as "a modern health resort" that treated "convalescents, neurasthmics, cases of nervous exhaustion, rheumatics or those whose health has been impaired by disease or by physical or nervous strain." Day's establishment recommended that their patients' "vigor and strength may be restored through wholesome food, regular hours of rest, open-air exercises, and scientifically administered baths and massage." (Courtesy NJHHS.)

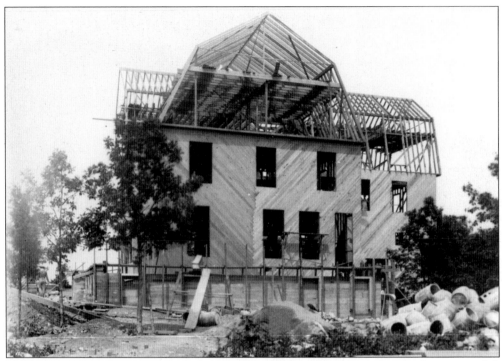

Idylease Inn was under construction in 1902. Note the construction worker on the extreme left of the photograph. (Courtesy NJHHS.)

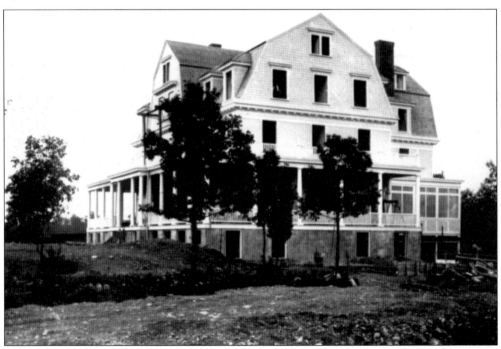

This photograph was taken shortly before opening day in 1903. (Courtesy NJHHS.)

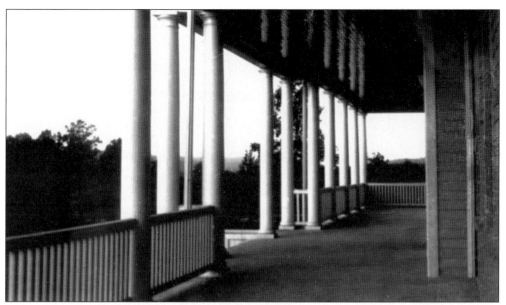

The veranda at Idylease extended around three sides of the building. Idylease promoted strolls on the veranda to promote relaxation in the mild Newfoundland climate. (Courtesy NJHHS.)

Idylease attracted visitors from throughout the area. The inn's carriages met any train arriving at the Newfoundland Station, which was less than one mile away. Guests attracted to the inn came seeking "rest, recreation, and change of environment." Idylease maintained a soothing and relaxing atmosphere, rather than clinical, to the delight of its patrons. Advertising literature described the setting as follows: "It . . . forbids anything suggestive of a hospital atmosphere, and requires the exclusion of incurables, consumptives, mental cases, alcoholics and drug habitues." (Courtesy NJHHS.)

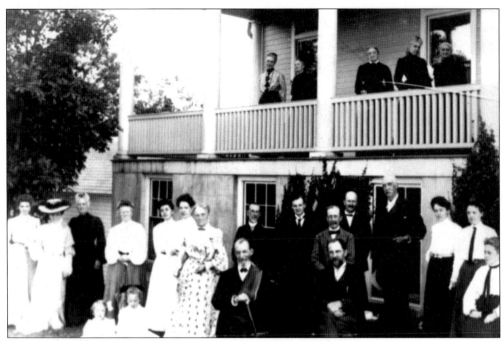

Founder Dr. Edgar Day is in the foreground of this picture of a lawn gathering at Idylease Inn. (Courtesy NJHHS.)

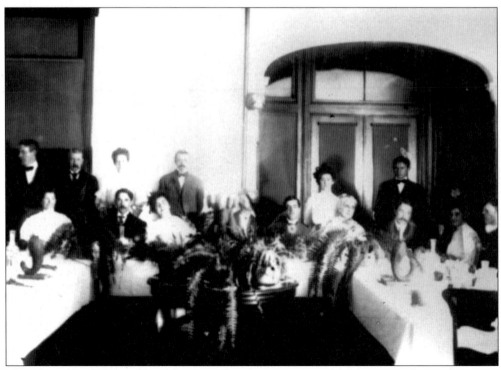

This formal gathering takes place in the dining room at Idylease in the early 1900s. (Courtesy NJHHS.)

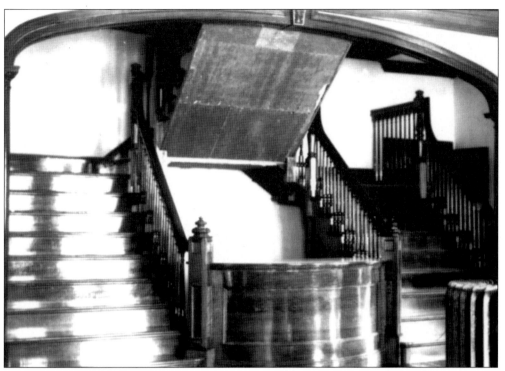

This majestic all-wood staircase was at the entry to Idylease. (Courtesy NJHHS.)

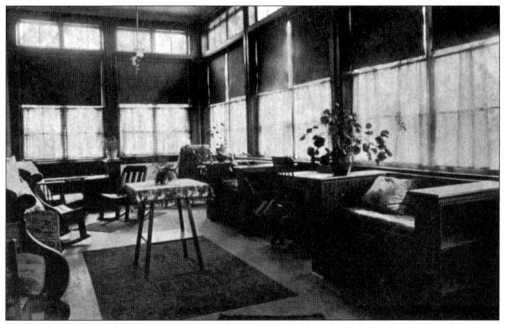

The sun parlor at Idylease was where guests could read and enjoy conversation. (Courtesy William Wurst.)

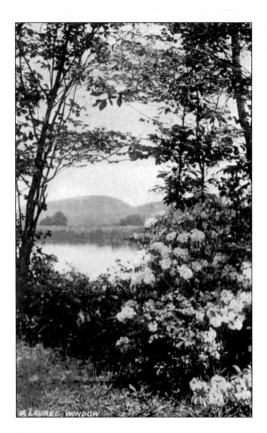

This "Laurel Window" postcard, issued by Idylease, promoted the scenery around the inn. (Courtesy NJHHS.)

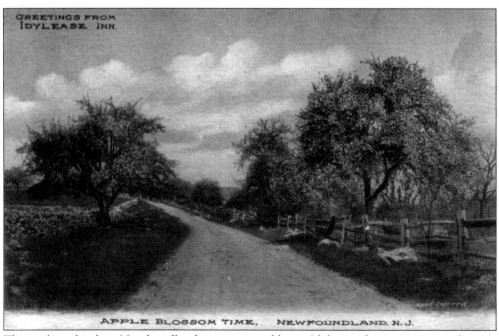

The apple orchards in Newfoundland were captured by an Idylease advertising postcard.

Seven
BROWN'S INN

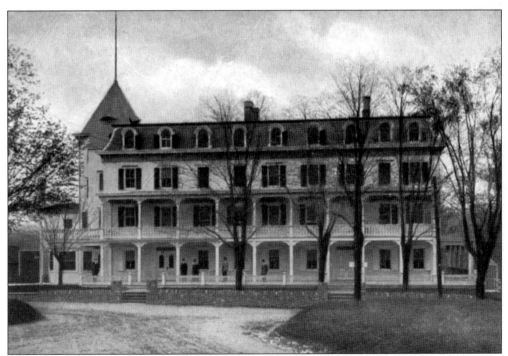

Brown's Inn was located at the junction of present-day Route 23 and Green Pond Road. The bandstand of the hotel still exists at that corner along with the railroad depot building, which was for the Newfoundland stop on the New York, Susquehanna, & Western Railroad. The property is now owned by Jefferson Township. (Courtesy William Wurst.)

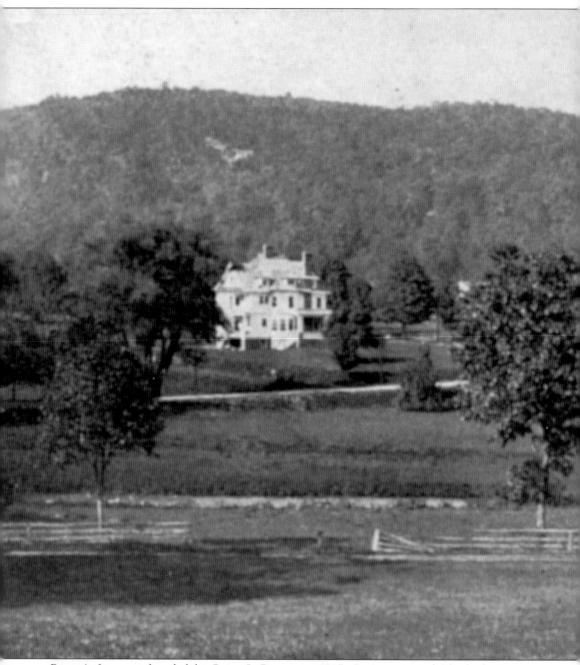

Brown's Inn was founded by Peter J. Brown in 1817. Brown married Elizabeth Kanouse, daughter of John George Kanouse, who had emigrated to Newfoundland from Holland with his family in 1720. The Kanouse family property was located off nearby (present-day) Kanouse Road. The family cemetery still exists on the site. Brown managed Brown's Inn until 1844,

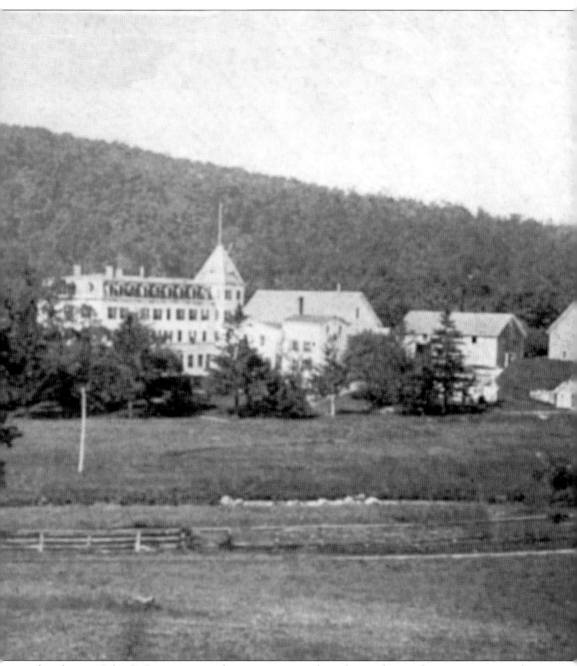

when his son John P. Brown assumed management, enlarged it, and turned it into a renowned resort for residents of the region. John P. Brown died in 1893 and his son Theodore Brown assumed proprietorship.

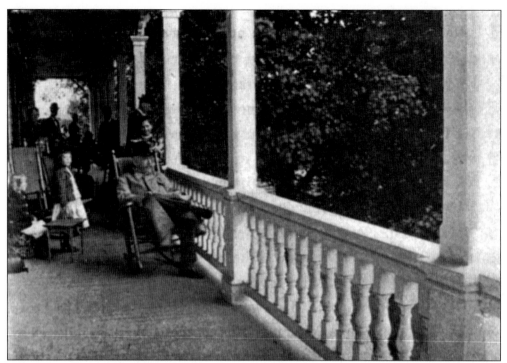

Pictures of the veranda at Brown's Inn were used to promote the comfortable Newfoundland climate for rest and relaxation. They noted that "Newfoundland is free from Malaria, Mosquitoes, and all conditions detrimental to comfort and health."

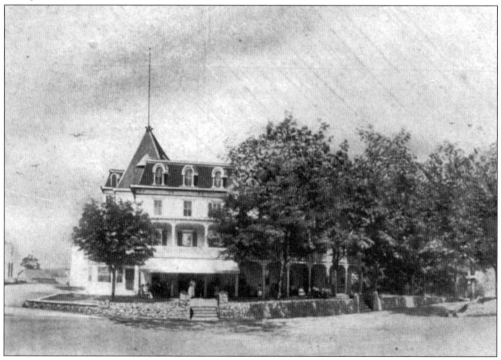

Brown's Inn is shown from the intersection of Route 23 and Green Pond Road.

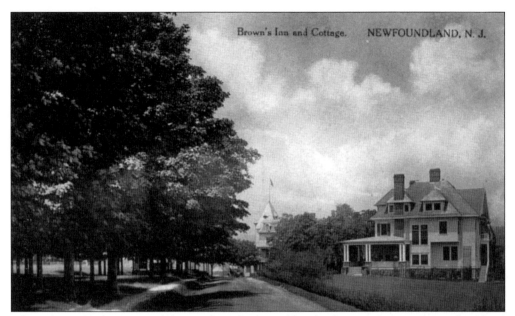

John P. Brown, who managed the inn from 1844 until his death in 1893, was apparently "a hard man to get the best of." Local legend has carried down the story of a farmer who visited the inn with his horse, wagon, and an empty chicken crate. After sharing a few drinks at the bar, the farmer went outside to his wagon, opened the crate, and returned to the bar announcing that some "sneaky critter" had released all his chickens. Brown, a gracious host, offered to refill the crate with a dozen of the inn's fine hens, which the farmer accepted. Brown, "a pretty slick trader himself," was not fooled for a moment. Later that year, the farmer stopped by to purchase some coal oil. He loaded up the barrel and drove his wagon home. However, when he tapped the barrel he found he had been "burned"—he had been sold a barrel of water.

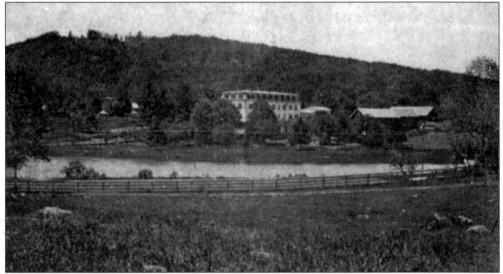

Brown's Inn was part of a nearly 1,000-acre estate, which included a livery stable; a farm that furnished the inn with fresh fruit, vegetables, milk, butter, and eggs; and a private pond, used exclusively by guests of the inn. There was also a general store on the property. This building, nestled between the north and south lanes of Route 23, is currently an electrical supply store.

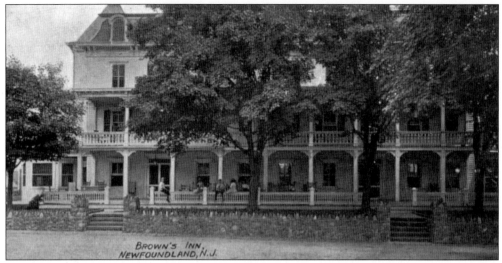

BROWN'S INN,
NEWFOUNDLAND, N.J.

E. Hewitt, a British citizen visiting Newfoundland in 1819, wrote the following account of his stay at Brown's Inn: "This afternoon, completely drenched with rain, we staid at a tavern newly erected, called Newfoundland. Here we procured a small private room and a good fire, dried our clothes, and got tea very comfortably. Our landlord, a very intelligent man, spent the evening with us, and related several interesting anecdotes of General Washington, with whom he was personally acquainted. I observed he was always addressed with the title of Squire, being a magistrate. . . . Bears, deer and wolves are very numerous in this neighborhood in the fall. A barn not exceeding 60 feet by 30 costs here about $125; shingles or wood tiles, $15 to $20 per thousand. The whip-poor-will we heard for the first time at this place, repeating its plaintive notes through the whole night. . . . Our accommodations at this place were very comfortable, and our charge, including hay, one peck of Indian corn, our room, fuel, liquor, one pound of butter, what milk we chose, and tar and tallow for our wagon, three-quarters of a dollar. I gave our kind host one dollar, which he accepted with reluctance; and at our setting off, he prepared us a quantity of egg-nog, a mixture of apple spirits, eggs and milk. Terrible roads still, and the bridges over the small streams nothing more than poles laid across."

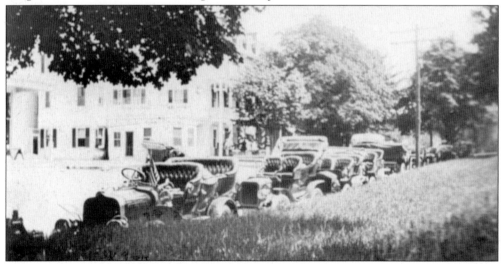

This c. 1907 photograph was taken on a busy day at Brown's Inn, as evidenced by the long line of empty automobiles outside it. (Courtesy WMM.)

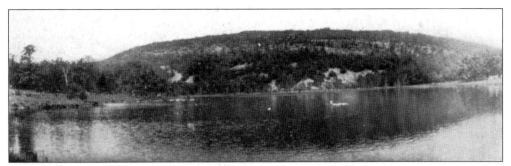

The pond alongside Brown's Inn and Mount Brown is pictured here.

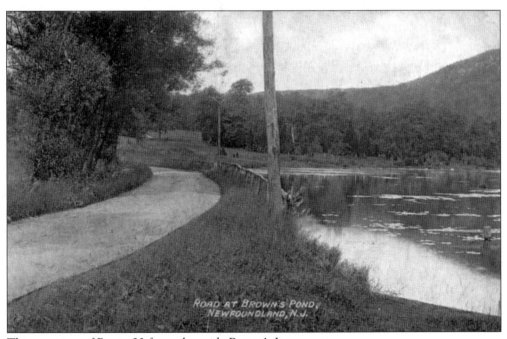

ROAD AT BROWN'S POND,
NEWFOUNDLAND, N.J.

This is a view of Route 23 from alongside Brown's Inn.

The inn was promoted as a source of comfort and health for its patrons. It included local excursions in the relaxation program. "Fresh air, charming scenery, and excellent roads leading out in many directions cause driving to be a delightful means of recreation."

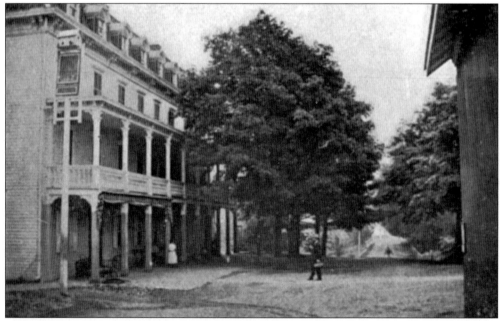

Brown's Inn made every effort "to secure comfort and homelikeness rather than unfashionable." Still, the inn was outfitted with many custom features, such as steam heating for the building (in addition to open fireplaces) and pure running water, which was pumped from a local mountain spring to the hotel via an underground iron pipe. (Courtesy Harry Rescigno.)

Eight

THE HORSE SHOE LOG (MOE'S) TAVERN

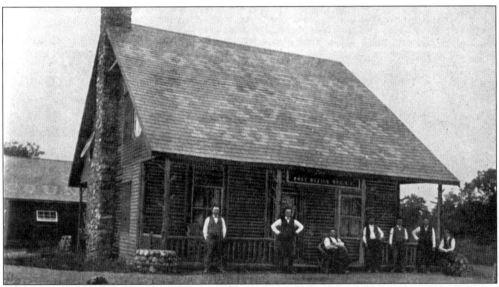

The Horse Shoe Log (Moe's) Tavern was built in 1903 by Ira W. Moe. The tavern was built in Moe, New Jersey, which is now Upper Greenwood Lake. Moe was the area's post office designation from 1896 until 1921, when it was determined that there was an insufficient number of year-round residents to justify a separate post office. The tavern was an extremely popular stop for local residents and visitors and offered quality country fare and a unique atmosphere. According to an advertising card, Moe's Tavern was located "40 miles from New York City by rail, 5 miles inland, on top of a high mountain, 1,500 feet above sea. It is high and dry with cool nights. I hereby certify that this 14-room Horse Shoe Log Tavern and its furniture is all built from logs. It is the neatest, most unique, odd, comfortable building I have ever seen and is brim full of novel ideas and well worth your while to make a special trip to visit it. Open the year around. All Trains met by appointment." (Courtesy Stephen M. Gross.)

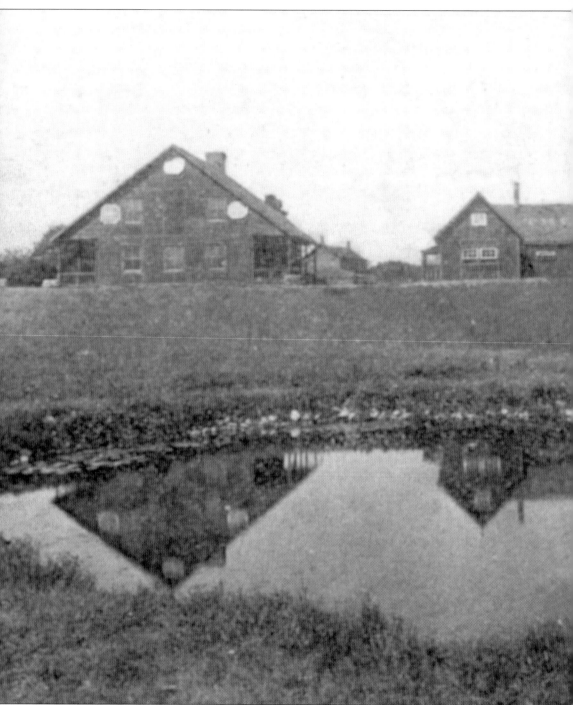

The tavern, the powerhouse, the Horse's Friend, the Raccoon Den, and the bridge "down by the spring" are all on the way to Cosey Corner. This postcard advised the holder to reverse it (turn it upside-down) for its "reflection effect." Other advertising materials from the tavern reaffirmed these details, such as the following amusing verse: "The Erie on its Greenwood Lake Division, makes your forty miles an early mission, and giving the landlord a previous

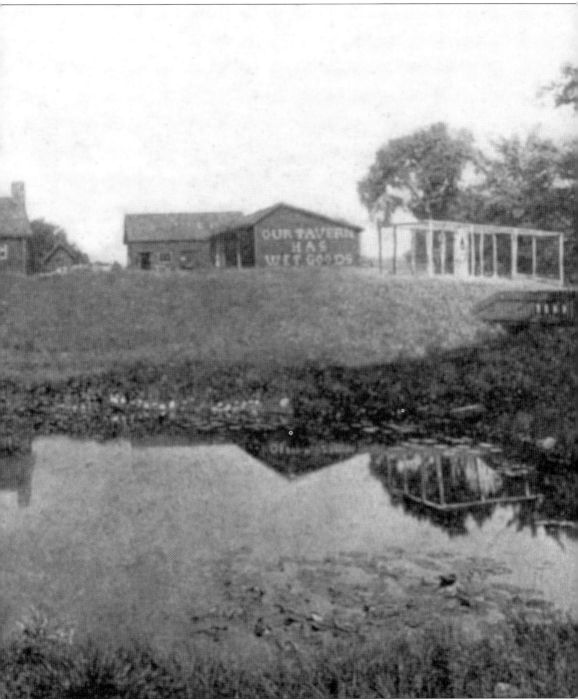

notification, he will meet you at Hewitt Station. A six-mile (the most picturesque in all creation), sharpens the appetite and produces a sublime sensation, that prepares you for a warm collation." Moe's menu notified patrons: "If any of YOUR FRIENDS would like to visit this quaint log tavern and have not the car fare TELL THEM to write Moe for a Railroad pass. THEY'LL GET IT!" (Courtesy Stephen M. Gross.)

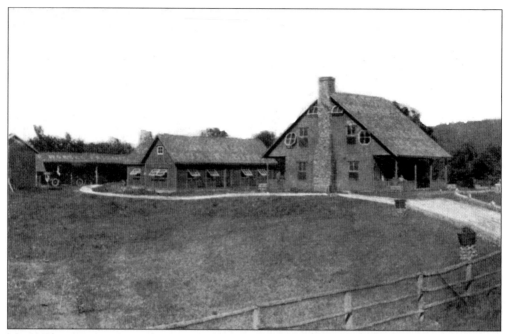

Moe's Tavern's promotional materials described an "odd, artistic, catchy" establishment. This view shows the tavern and surrounding buildings. (Courtesy Stephen M. Gross.)

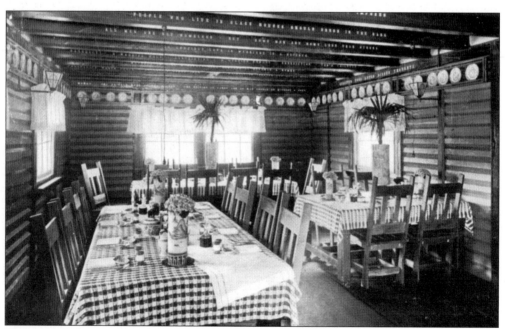

The tavern's "large, odd and attractive Dining Room" is where "Genuine Country Dinner" was served. The room's color scheme was blue and white. (Courtesy Stephen M. Gross.)

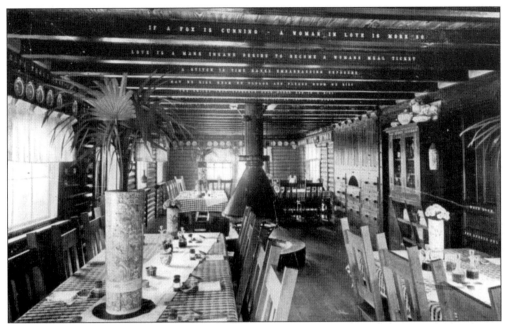

A full-length view of the dining room reveals the inscriptions carved into the wooden beams. They read: "If a fox is cunning—a woman in love is more so;" "Love is a mans [*sic*] insane desire to become a womans [*sic*] meal ticket;" "A stitch in time saves embarrassing exposure;" and "May we miss whom we please and please whom we miss." The large circular fireplace in the room's center burned coal or wood in the winter; in summer it was converted into a fountain in a most "novel and unique fashion." (Courtesy Stephen M. Gross.)

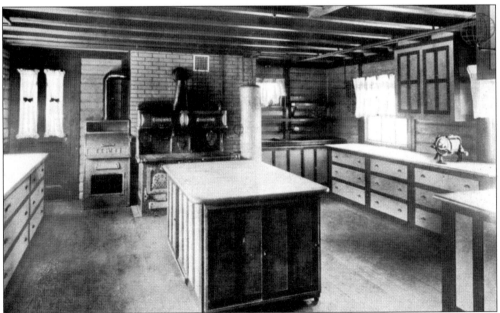

The tavern's famous and modern kitchen was where the country dinners were prepared. Ira Moe took great pride in his kitchen and guests were always welcome to come and inspect it. (Courtesy Stephen M. Gross.)

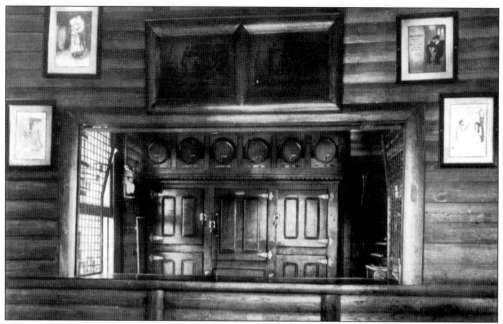

The Horse Shoe Log Tavern's famous café, called the Good Wet Goods Department, was renowned for its Wild Cherry Tonic. (Courtesy Stephen M. Gross.)

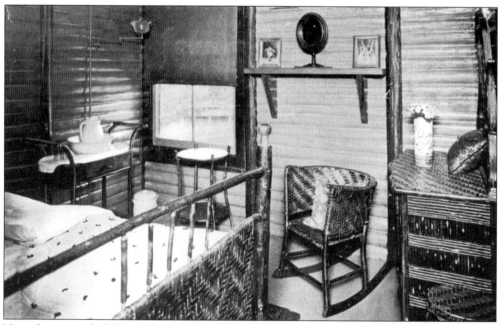

Note the woven bed frame, chair, and bureau top in this view of a second-floor bedroom at the Horse Shoe Log Tavern. Attention was paid to detail, as evidenced in the delicate glass lamp and thoughtful touches such as the vase of flowers on the bureau or the small mirror on the wall shelf. (Courtesy Stephen M. Gross.)

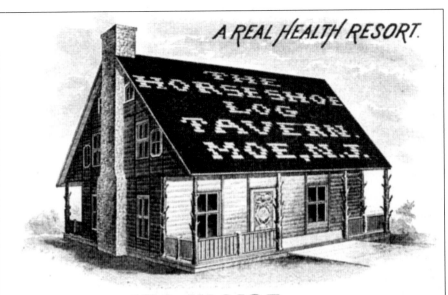

A REAL HEALTH RESORT.

IRA W. MOE, PROP.

(P.O.) MOE, N.J.
R. R. STATION, HEWITT, N.J.

THE FRONT DOOR.

40 miles from New York City by rail, 5 miles inland, on top of a high mountain, 1,500 feet above sea. It is high and dry with cool nights. I hereby certify that this 14-room Horse-Shoe Log Tavern and its furniture is all built from logs. It is the neatest, most unique, odd, comfortable building I have ever seen and is brim full of novel ideas and well worth your while to make a special trip to visit it. Open the year around. All trains met by appointment.

BACK OF THE FRONT DOOR.

From _____

This advertising postcard from Ira W. Moe promoted the Horse Shoe Log Tavern, a "Real Health Resort." The door shown on the postcard was saved from the demolition of the tavern and given to the West Milford Museum. Sadly, before the museum building's renovation, a blizzard caused the roof of the storage shed to collapse. The shed was bulldozed to the ground before the door and other artifacts could have been saved by local historians. (Courtesy Stephen M. Gross.)

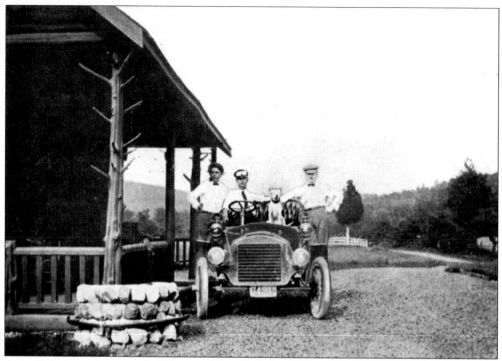

A sporting group from nearby Warwick, New York (including a dog), arrives at the Horse Shoe Log Tavern "for a few Wild Cherry High Bells." (Courtesy Stephen M. Gross.)

An aerial view shows the Horse Shoe Log Tavern and surrounding country from a mile away. This stretch is along what is today Warwick Turnpike. (Courtesy Stephen M. Gross.)

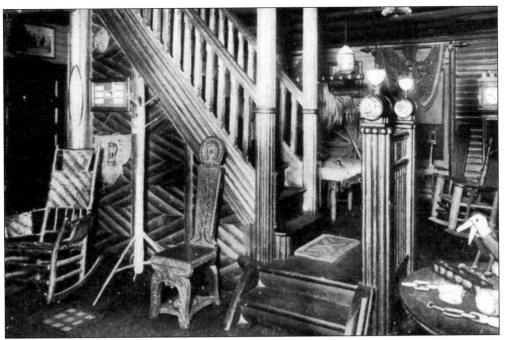

This is the eclectic sitting room and reception room of the Horse Shoe Log Tavern. (Courtesy Stephen M. Gross.)

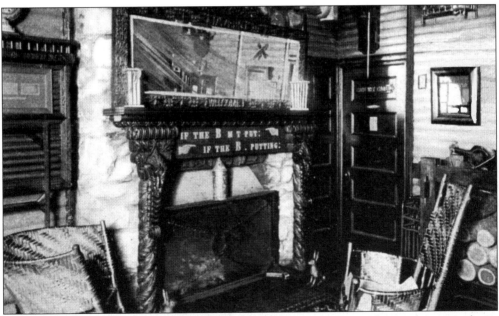

A second picture of Moe's famous sitting room shows the hand-carved mantel, woven chairs, wood rack, and the "Roll of Honor." The sign under the mantel reads, "IF THE B M T PUT: IF THE B PUTTING." It is now in the permanent collection of the West Milford Township Museum, where staff and visitors engage in lively speculative debate on its meaning. (Courtesy Stephen M. Gross.)

Room No. 6, on the second floor of the Horse Shoe Log Tavern, was known as a "Room of Jollies." Patrons reportedly laughed away many happy hours in this room, chatting and playing cards. Note the woodworking on the underside of the staircase in the hallway. (Courtesy Stephen M. Gross.)

Room No. 4 on was extremely popular on rainy days and was where patrons enjoyed listening to the patter of raindrops on the roof and relaxed in the soft light from the octagonal window. (Courtesy Stephen M. Gross.)

Ira W. Moe's private residence was located approximately 300 feet from the tavern. (Courtesy Stephen M. Gross.)

Jack was the Horse Shoe Log Tavern's pet raccoon. Jack had his own raccoon pen a short distance from the tavern and its outbuildings. According to the reverse of this postcard, "not one person in a million has ever seen a Raccoon in this position." (Courtesy Stephen M. Gross.)

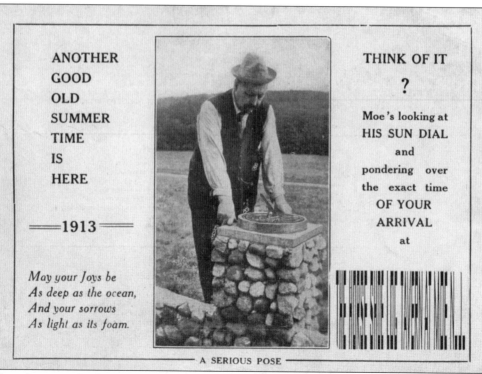

This advertising leaflet from 1913 shows the eccentric Mr. Moe pondering his unique outdoor timepiece. (Courtesy WMM.)

Nine
THE GLORIA

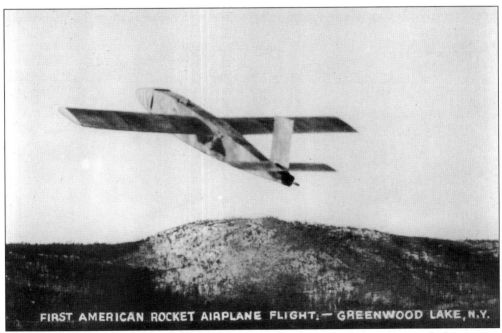

This postcard was issued to commemorate the *Gloria* rocket flights that made history on February 23, 1936. (Courtesy WMM.)

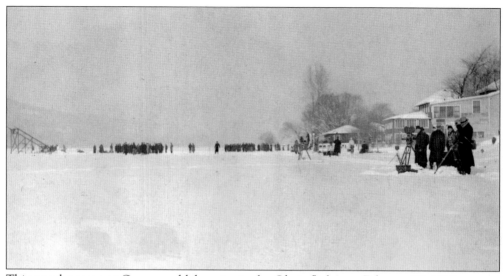

This was the scene at Greenwood lake prior to the *Gloria* flights on February 23, 1936.

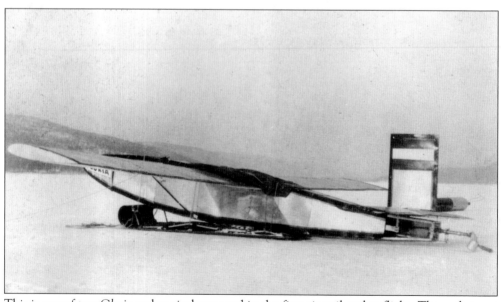

This is one of two *Gloria* rocket airplanes used in the first airmail rocket flight. The rocket was tied to a toboggan prior to one of its test flights on February 23, 1936. The two rockets were approximately 14 feet long with a 16-foot wingspan and were made of duralumin, a custom alloy. (Courtesy WMM.)

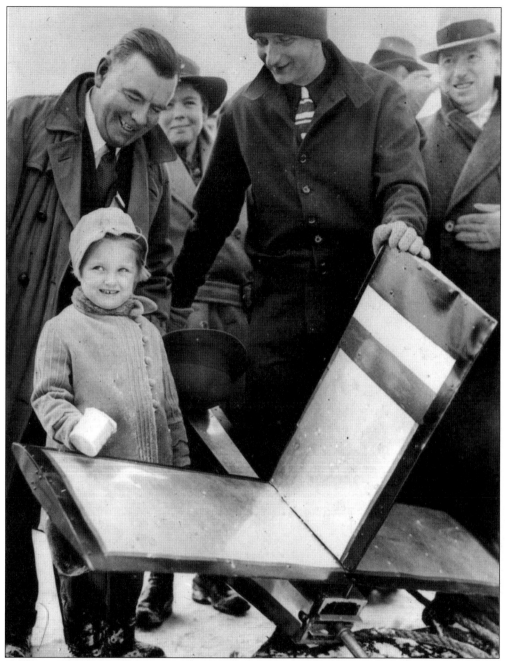

Six-year-old Gloria Schleich christens the *Gloria* rocket with her tin cup filled with snow. Radio personality Capt. Tim Healy is standing immediately behind her. The event was covered by a plethora of newsreel cameras and broadcast live by Bob Trout on CBS radio. Greenwood Lake resident John Schleich (who later became mayor) had conceived of the rocket launch along with New York stamp dealer Fred Kessler, who wished to prove that rockets could be used to rapidly transport mail across long distances. Gloria, Schleich's daughter, became a favorite among the rocket's crew members. It is for Gloria that the rockets were named. (Courtesy WMM.)

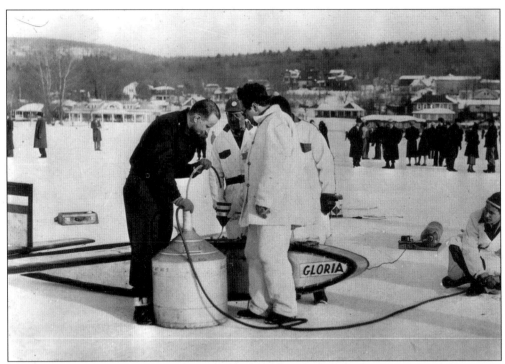

The rockets were fueled by three tanks, one holding liquid oxygen at –200 degrees centigrade, one holding nitrogen gas, and the third holding a mixture of alcohol, gasoline, and methane. (Courtesy WMM.)

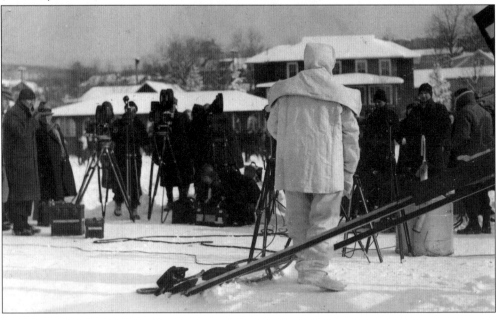

Willy Ley, the rockets' inventor, addresses newsreel reporters while wearing a fireproof asbestos suit. Ley was a research engineer who came to the United States after fleeing the Nazis in 1934. He later worked with the national space program and authored numerous books on space flight prior to his death in 1969. (Courtesy WMM.)

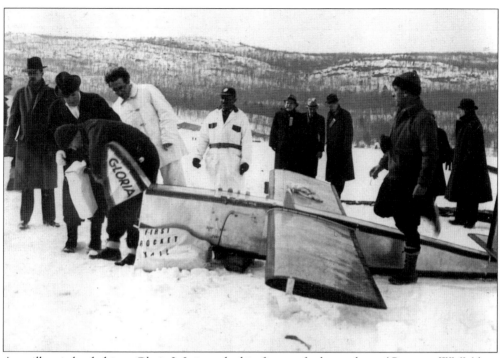

A mailbag is loaded into *Gloria I*. It is packed in fireproof asbestos bags. (Courtesy WMM.)

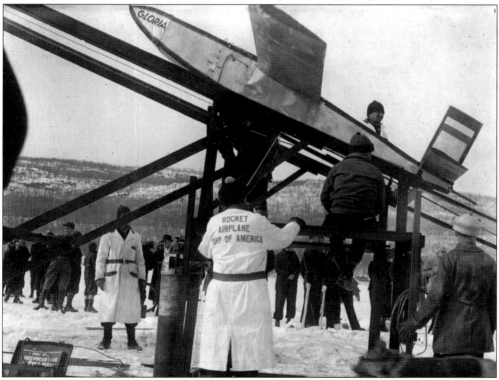

Engineers secure *Gloria I* onto a specially designed catapult for the launch by Mike Morin Sr. of the Greenwood Lake Launch Works. (Courtesy WMM.)

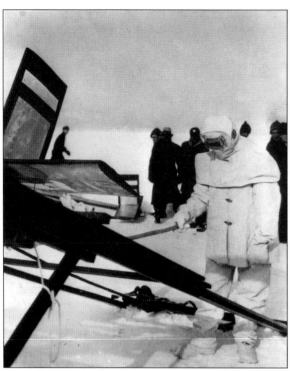

Willy Ley sets fire to the fuse connected to the rocket motor. (Courtesy WMM.)

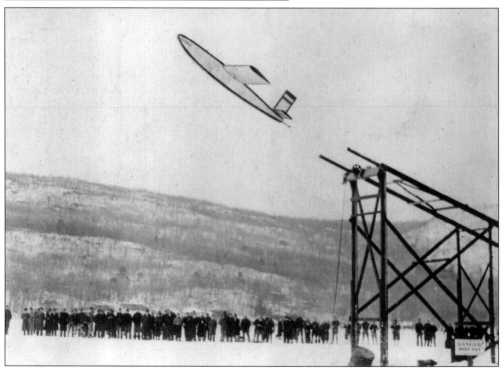

Gloria I took off from the catapult, rose 40 feet into the air with flames sputtering from its tail, and then dove and crashed into the ice. Mail form *Gloria I* was removed from the nose cone and loaded into *Gloria II.* (Courtesy WMM.)

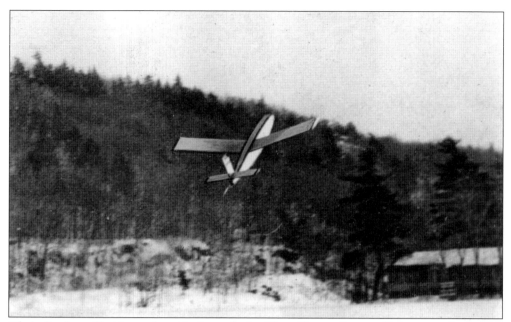

Gloria II takes off without the aid of a catapult. *Gloria II* initially rose 50 feet into the air and then repeatedly landed and rose until skidding across the state line, approximately 2,000 feet from the starting point. (Courtesy WMM.)

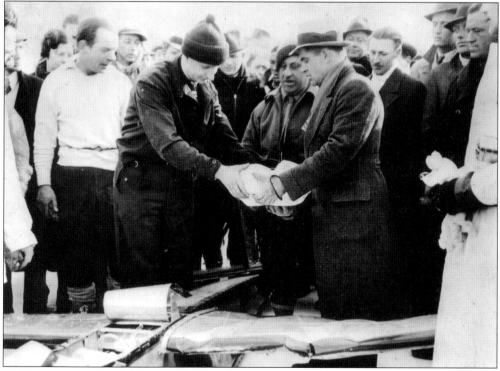

Mailbags are retrieved from *Gloria II* and handed by Fred Kessler to Postmaster White of Hewitt. Kessler was an authority on and collector of airmail stamps who had promoted the flight. (Courtesy WMM.)

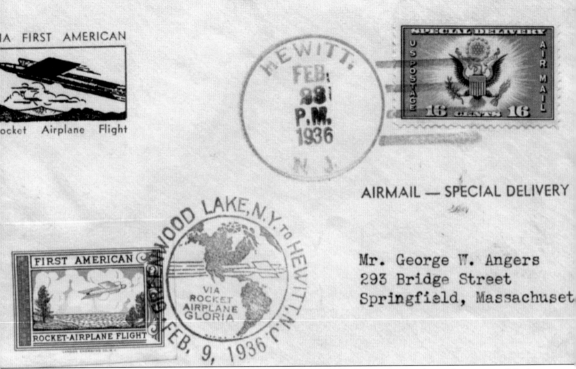

This is some postmarked mail from the first mail rocket flight to Hewitt from Greenwood Lake, New York. The rocket held a mailbag containing 4,323 commemorative envelopes and 1,826 postcards marking the occasion. (Courtesy WMM.)

Ten

WEST MILFORD'S HIGHLANDERS

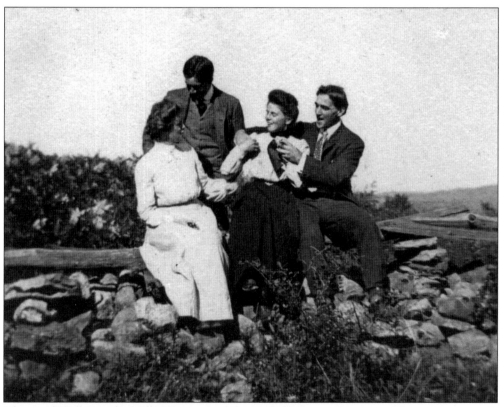

Clara and Will Moody, Mills Hopper, and Gertrude Terhune, shown on Warner's stone wall, enjoy a sunny afternoon together on September 24, 1905.

Viola Hopkins and her dog were photographed near White's sawmill in 1907.

Doris, Ada, and Austin Thompson were photographed on October 8, 1912, near the hemlocks on their property. Doris is three years old in this photograph and holds one of the family chickens, Bantam.

Mildred and Earl Brower rest along Warner's stone wall on July 22, 1906.

Mills Hopper and Gifford Francisco were also photographed that summer by Gertrude Terhune on Warner's stone wall.

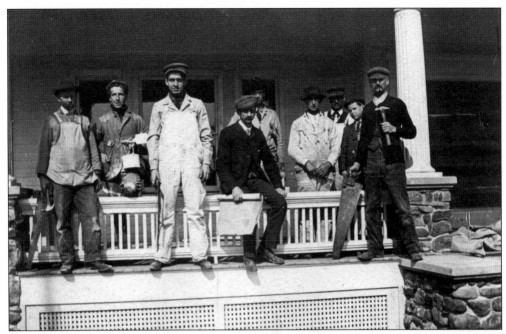

Workers were finishing the Warner house on April 5, 1906. Gertrude Terhune listed some of "Uncle Frank's contractor men" in the photograph as (not in order) Father, Parker, Joe Terhune, Eddie Sisco, Steve Van Orden, Mills Hopper, Walter Terhune, and Jake Vreeland.

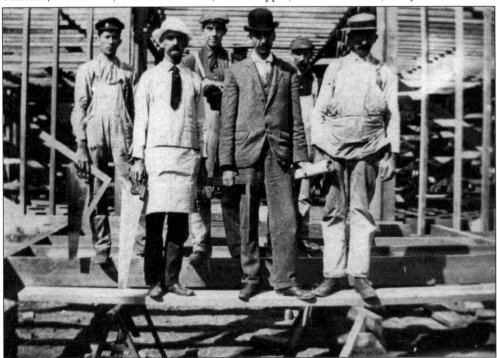

The crew was working on construction of Warner's home, Buena Vista, in September 1905. Gertrude Terhune listed them as Uncle Frank, Father, Mills Hopper, Ed Hall, George Harford, and "some fellow by the name of Cahill."

Walter Rue Murray Jr. was only eight weeks old when this photograph was taken of him and his mother on September 28, 1905.

Louise Hopper is shown in her all-white paper suit in the Hopper's backyard at Maplehurst. The dress was a masquerade party dress. The photograph was taken on New Year's Eve 1906.

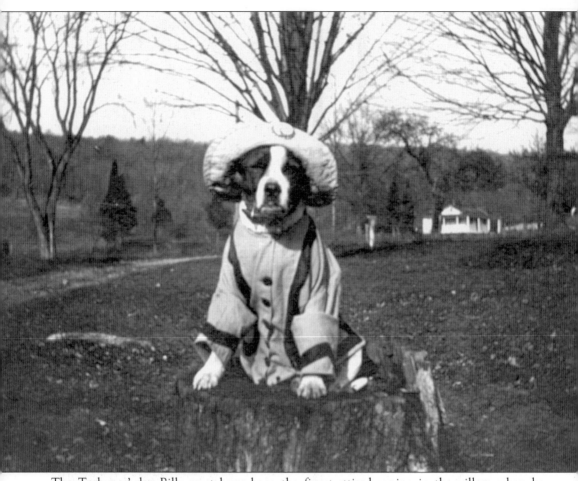

The Turhunes' dog Billy must have been the finest-attired canine in the village when he donned his special frock and Easter bonnet for this *c.* 1913 picture.

Bert Manchee plays on the Manchee farm. (Courtesy NJHHS.)

John L. White is shown at his sawmill at the bottom of Warwick Road. According to Gertrude Terhune, White died of heart failure on November 20, 1905, at age 73, "quite an old man." (Courtesy NJHHS.)

Bert Manchee and Helen Mertz pose for this picture. (Courtesy NJHHS.)

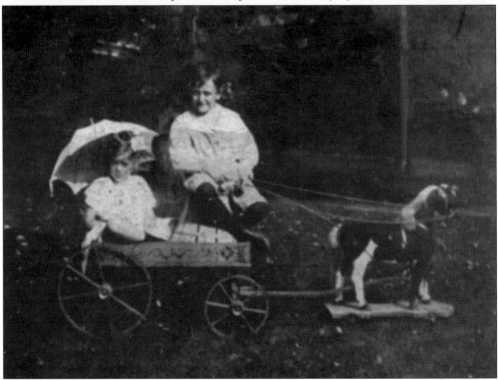

The Manchee children are shown here. (Courtesy NJHHS.)

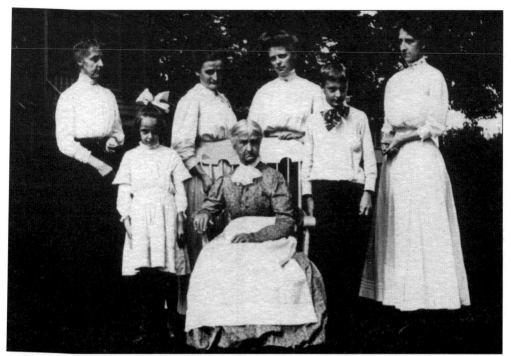

At "Grandma" Terhune's 85th birthday party on June 27, 1910, Gertrude Terhune notes that those pictured are, from left to right, "Aunt Nora, Eleanor B., Aunt Edith, Grandma (sitting), me, Albert Bates and Aunt Clara."

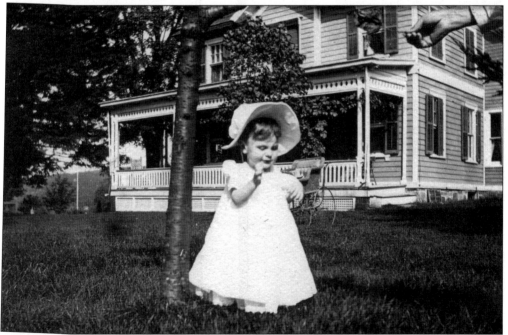

This photograph was taken on August 30, 1906, when Walter Rue Murray Jr. had grown to 13 months. Photographer Gertrude Terhune notes the presence of mother Mabel's hand in the upper right of the photograph, as Walter "couldn't stand up alone hardly."

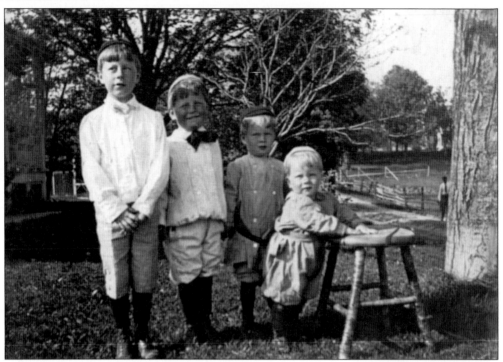

Arthur, Everett, Fred, and Bert Manchee are shown here. (Courtesy NJHHS.)

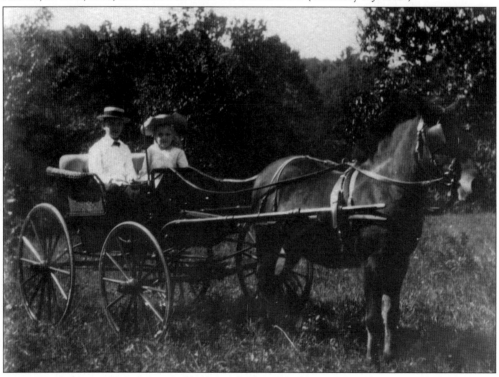

Gussie and Lizzie Warner were photographed with their pony Chico in their fields in September 1905.